Beautiful America's

Columbia River
GORGE

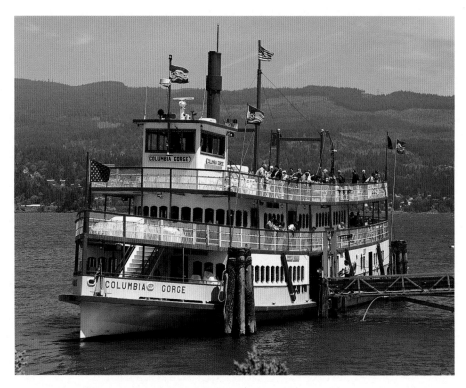

The famous sternwheeler Columbia Gorge

Cover photograph: Autumn splendor at Elowah Falls

Published by
Beautiful America Publishing Company©
P.O. Box 646
Wilsonville, Oregon 97070

Design: Michael Brugman
Linotronic output: LeFont Typography

Library of Congress Catalog Number 91-6783

ISBN 0-89802-573-7
ISBN 0-89802-567-2 (Paperback)

Printed in Hong Kong

Beautiful America's

Columbia River
GORGE

Photography by Craig Tuttle

Text by Linda Sterling-Wanner

Beautiful America Publishing Company
T.M.

To Charlotte, Linda, Merry, and Michael

The Columbia River Gorge

The breath of history and legend that permeates the Columbia River Gorge creates an undeniable presence. This presence floats among the shreds of mist off Bridal Veil Fall; it is a petroglyph embedded in the sheer walls of a basalt cliff; a spirit howling round the canyon when the wind blows at midnight.

Once bathed in this aura of splendor known as The Gorge, one easily accepts legend as truth. One of the favorite legends, and there are as many versions as native Indian tribes, is told about the forming of the Guardians of The Gorge. The Klickitat Indians tell this version.

> "Tyhee Saghalie, chief of all the gods, was a tired old man when he began searching for the most beautiful place on earth. He came from the far North, traveling downriver with his two fiery sons, Klickitat and Wyeast. What they found was a land suitable for this god of gods, but Tyhee Saghalie's sons spoiled his great pleasure by quarreling over the land. The master god stopped their quarrel by shooting two arrows from his great bow. One arrow flew to the west, one to the north.

> "Klickitat followed the northern arrow and claimed his land there, naming his people after himself. Wyeast moved west to live beside the Willamette River. He named his people the Multnomahs.

> "Wise old Tyhee Saghalie knew there should be a

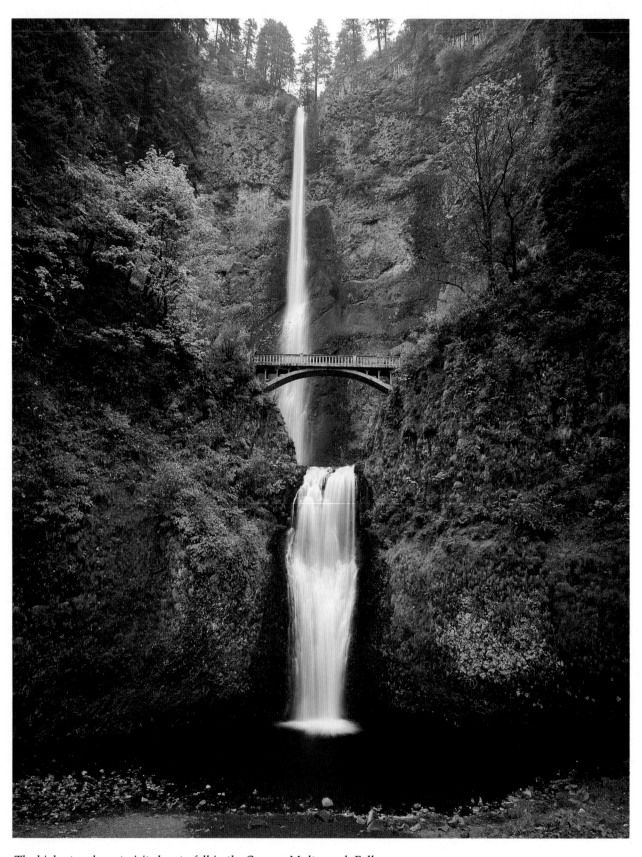

The highest and most visited waterfall in the Gorge—Multnomah Falls

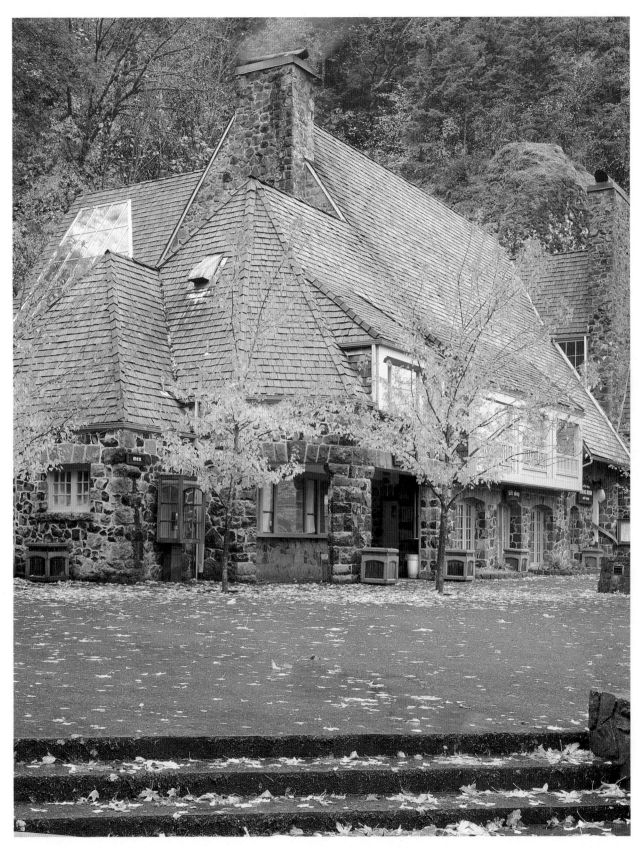

On the Scenic Highway, the beautiful Multnomah Falls Lodge

boundary between his sons so he raised the mountains on each side of the river. He kept the mountains low however— perhaps to keep his people from the same cold he had known in the great North. Then he built the most stunning structure ever seen by man—Tahmahnawis, the Bridge of the Gods—so that his sons and their children and grandchildren would not be forever divided. Tahmahnawis would allow them to cross the river in safety.

"The great god's goodness caused him to make a serious mistake. The problem started with a witchwoman named Loowit.

"Loowit was the ugliest woman on earth. No one would have approached her if she had not found a way to make herself wanted: Loowit had charge of the only fire in the world.

"Though Loowit was ugly, she was not without heart. It hurt her to see the tribes deprived of fire to cook their food during the long, wet winters—without fire to warm the women and children. She decided to make a gift of the fire to Tyhee Saghalie.

"The great god was pleased beyond measure and in gratitude he offered Loowit anything she wanted. Naturally, she asked to be beautiful. Tyhee Saghalie granted her request.

"Soon, Klickitat and Wyeast fell in love with Loowit. Trouble began because she could not make up her mind who she should marry. The tribes began to quarrel over which of their chiefs most deserved to marry the beautiful Loowit. War soon broke out between the people.

"The Tyhee of all gods felt angry and hurt. To put an end

to the war he destroyed the Bridge of Gods and put Loowit, Wyeast and Klickitat to death.

"The great god suffered because of what he had been forced to do. Since his sons and Tyhee had been beautiful in life, he wanted them to be admired forever, so he made Klickitat into Mt. Adams, Wyeast into Mt. Hood and Loowit into Mount St. Helens.

"His beautiful bridge fell into the river to create the great Cascades."

So goes the Indian explanation for the collapse of the colossal natural rock formation that once spanned the Columbia River.

This same unexplainable sense of magic in the land is carried through in the words written three-quarters of a century ago by Samuel Christopher Lancaster, the highway engineer who built a road through the Columbia River Gorge. Geological descriptions of the formation of The Gorge abound, but Lancaster's words have an eerie beauty tainted lightly with fact, that conveys more than mere scientific fact could ever disclose.

"There was a time when the waves of a nameless ocean kissed the Western slopes of the Rocky Mountains—when unborn continents lay still in the dark, cold womb of fathomless seas. Even then, far—far offshore, the voice of God was heard, and out of the boundless deep He lifted up a mountain range. From North to South it rose like some leviathan stretched at full length, with head and tail touching the mainland, and the Cascade and Sierra Nevada Ranges

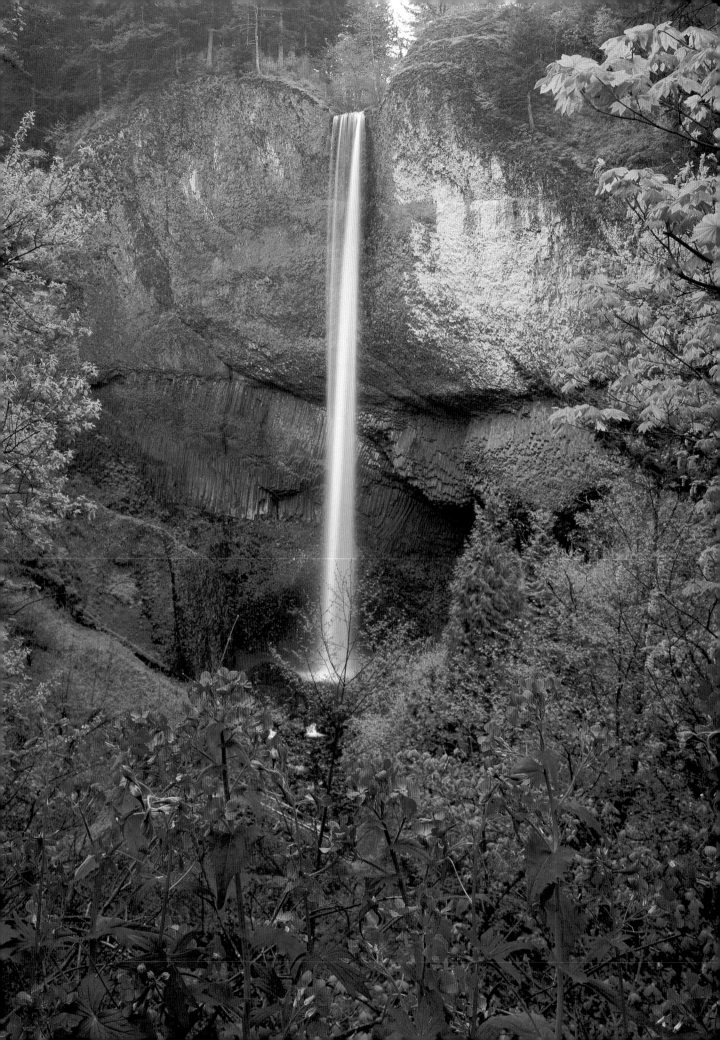

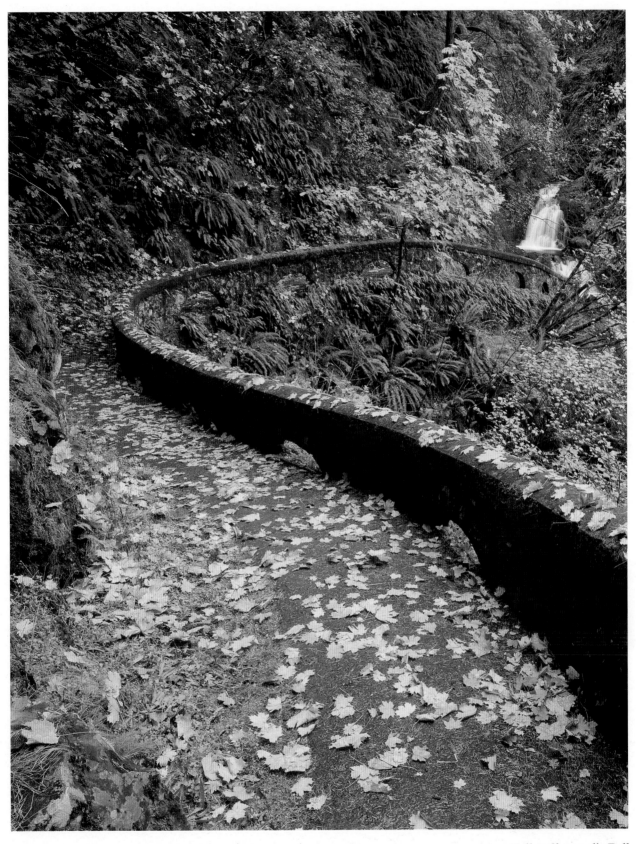

Fall at Shepperd's Dell

Opposite page: Spring at Latourell Falls

were created, thus forming an inland sea, a thousand miles or so in length.

"How fearful were the sounds! How dark the skies! The earth groaned and trembled as if in travail when this new land was born; the very foundations were broken up, and flames burst forth. The rocks were melted with fervent heat, and white hot magma streams ran down the mountainside into the sea. Steam rose in clouds—lightenings flashed—rain poured in torrents—thunder roared. The whole mass heaved, and rose, and fell, as a bosom moved with passion, until that day's work was done.

"When the sun broke through the veil, it shone on a naked land, its only clothing ashes—hot ashes—blowing, drifting everywhere.

"For centuries the most active volcanoes were at work. They built up mighty domes reaching into the skies, one mile, two miles, almost three miles high, until the icy-cold of the atmosphere, where they now reared their heads, exceeded the cold of ocean depths whence the uplift came.

"Time first closed the smaller vents and fissures, then hushed the greater ones. When the fires from within were extinguished, perpetual snow crowned the loftier peaks.

"These great snow fields moved slowly, sliding, pushing downward, producing many an avalanche, and glaciers extended far into the lower valleys.

"In their imperceptible movements these mighty glaciers wore through the lava beds in many places, cutting gashes hundreds of feet in depth, grinding to powder the older limestone and other rocks beneath them. These fragments

were mingled by the igneous mass, which He took from the very bowels of the earth. The little rivulets joined with mountain torrents to bring the product of the glaciers down into the valleys, where He spread it out, producing a soil rich in everything that ministers to man."

Lancaster went on to describe his idea of the formation of the Columbia River Gorge in a perfect symphony of words that captures its beauty today.

"Then the Prince of All Gardens planted the seeds of a thousand springtimes. Some flowers He made to grow high up in the clefts of the rocks, in fields of snow. The anemone and heather He planted a little lower down, just where the trees begin; and when He came to where the earth slopes gently out in upland meadows, jeweled with sparkling waterbrooks, He gave more freely of His abundance and carpeted the earth with flowers of every tint and hue. Alpine firs He planted here and there, grouping them, and adding others as He came down into the valleys, where He made the flowering shrubs and ferns to grow in the midst of dark, cool forests of great and stately trees, the shelter of His creatures.

"There is a beauty in the bare angles of the rocks which look down from the heights, where His fingers broke them. Here He rent and tore them asunder, to make room for one of earth's great rivers."

Lancaster's awe is expressed daily by those who pass through. The Gorge remains truly one of the most majestic areas in the world. With the Cascade Mountains rearing craggy

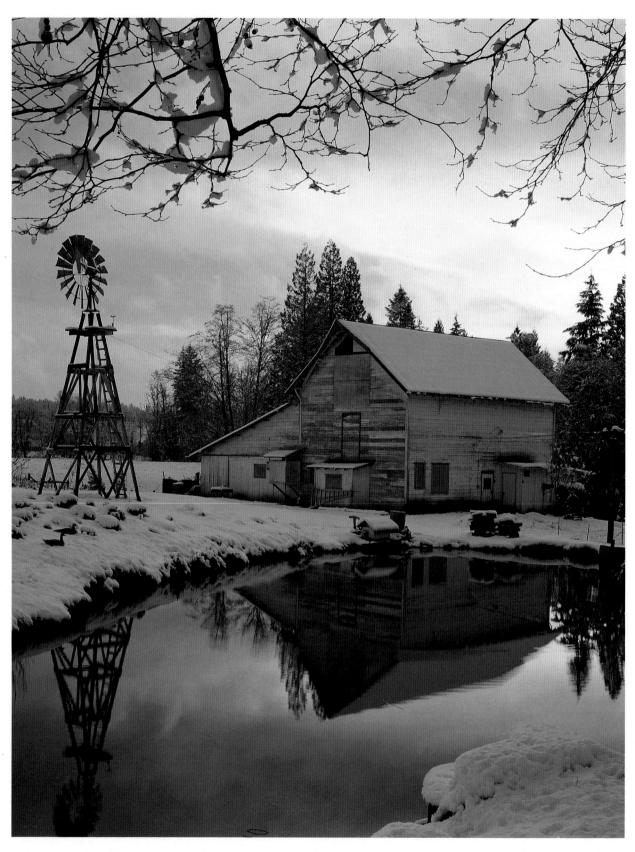

A beautiful winter sunset at a farm in Corbett

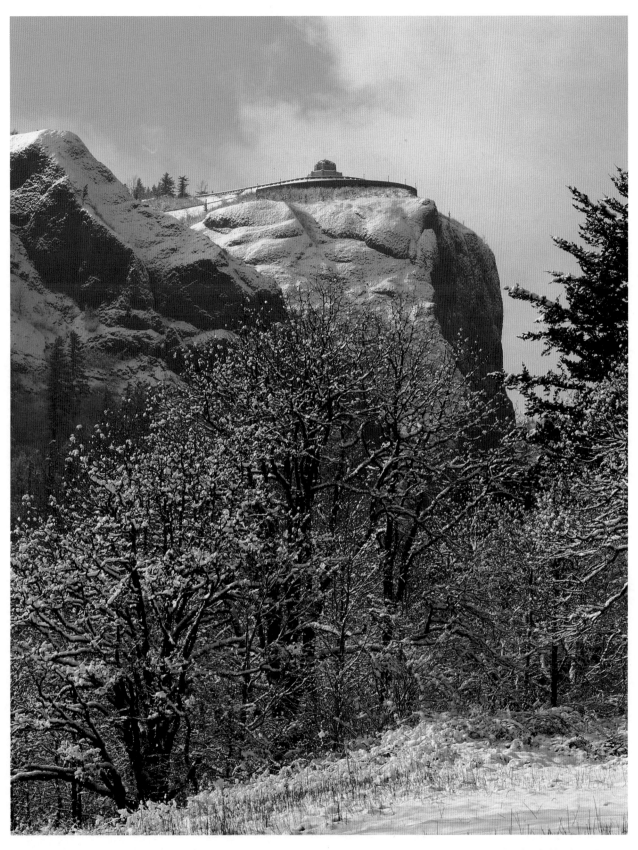

An unusual view of Crown Point with a fresh blanket of snow

heads to heights of up to 4,000 square feet on each side of the river, the Columbia surges through the great cliffs, creating the only sea-level break through the Cascade Range to the Pacific Ocean. Adding to the visual feast are nearly 75 waterfalls; hundreds of hiking trails for novices or experts; trees and wildflowers that are found, in some cases, only in this part of the world; and birds and animals of many species. When your sensations or your treking legs are overloaded, there are always the towns to visit, with their variety of attractions; the lazy lure of fishing under bright skies; or, for the spunky, the more modern thrills of windsurfing.

And then there is the great highway Lancaster built—great in the sense it was built with preservation of scenery being a primary objective, great too in the sense it was a miracle of construction for a time when only mule power and the energy of men could fuel its development. Panoramic views, picnic spots, and access to waterfall viewing were as much a consideration as whether automobiles could race from one side of the state to the other.

For a fascinating history of how the road was constructed, *Lancaster's Road, The Historic Columbia River Scenic Highway* by Oral Bullard provides in-depth historical information.

Much of the highway can no longer be traveled. The surviving stretches can be reached by taking Interstate 84 exits at either Troutdale, Lewis and Clark State Park, Corbett, or Bridal Veil. If you're traveling west, take the Dodson or Warrendale exit.

The richness of historical and scenic sights is intermeshed so stopping points specific to the Scenic Highway will be

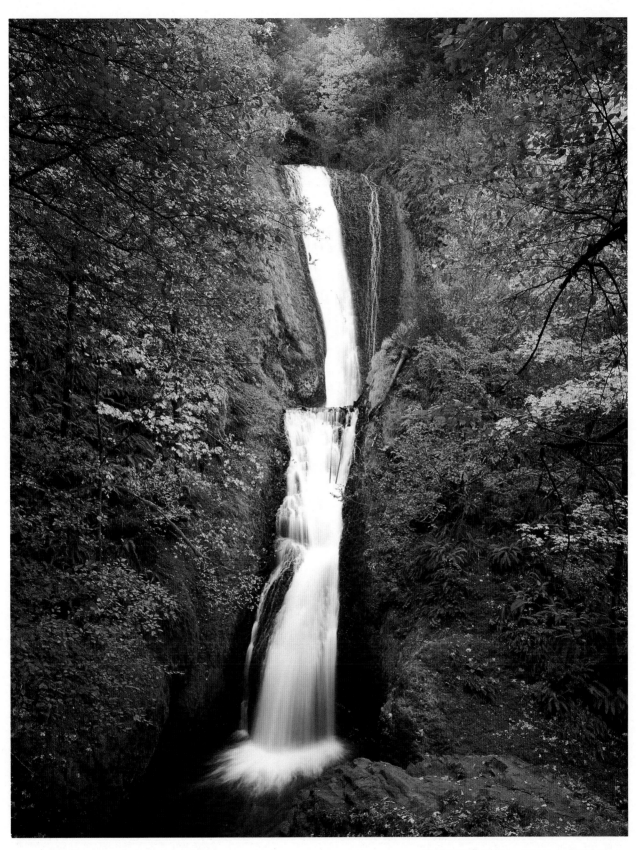

Bridal Veil Falls on the Scenic Highway

mentioned as such. Otherwise, we'll move from west to east on our Columbia River Gorge tour.

We begin our tour slightly northeast of Portland near the I-205 bridge where an Indian village site called Ne-er-cha-de-oo was discovered by Lewis and Clark. Clark wrote:

> "landed at a village of 25 houses: 24 of those were thatched with straw, and covered with bark, the other House is built of boards in the form of those above, except that it is above ground and about 50 feet in length. This village contains about 200 Men. I counted 52 canoes on the bank in front of this village many of them verry large and raised in bow. (They) gave us roundish roots about the Size of a Small potato which they roasted in the embers until they became Soft, This root they call Wap-pa-to."

Clark's second experience with the root wappato is told with a tang of humor.

It seems on the return trip an Indian near Washougal told him about the Willamette River, which the expedition had missed during their earlier explorations. So Clark went back to explore and stopped at the same village to purchase food.

> "I entered this house and offered several articles in exchange for wappato. They were sulkey and positively refused to sell any. I had a small pece o port fire match in my pocket, off of which I cut a pece and put it in the fire the port fire cought and burned vehemently, which changed the colour of the fire; which astonished and alarmed those nativs and they laid several parsles of wappato at my feet."

Although difficult to find, another Indian village site lay just west of Blue Lake (off Interstate 84). This village was once occupied by a tribe who called themselves the Nechacokee. The diaries of Lewis and Clark report there was one occupied house 226 feet long and sixteen feet wide. One woman, they went on to say, was badly marked with smallpox. While in the village, an Indian drew a map for Captain Clark of the Willamette River showing its tributaries, and the Indian villages and nations in detail.

The Scenic Highway begins with the Sandy River paralleling the road for a short distance. The Sandy has delightful swimming holes and is also known as a good fishing river. In spring, the smelt turn out in force, and fishermen have long dipped nets into the currents, harvesting these silvery fish.

The first significant point on the western end of the Columbia River Scenic Highway is Chanticleer Point. The property here was donated to the State Park system by the Portland Women's Forum and the park is named after that group. Here you'll find a marvelous view of the Columbia etched against a distant blue haze. The view to the east is Crown Point and the Vista House. Below is Rooster Rock, which was once the site of a salmon cannery. Rooster Rock has attained a popularity equal to that of Oregon's ocean beaches because of its long bathing beach which has a wide strip of shallow water that young people enjoy. The park can be reached from Interstate 84.

Crown Point State Park is a designated National Natural Landmark. Crown Point is the remains of a 25-million-year-old

The serene beauty of Benson State Park

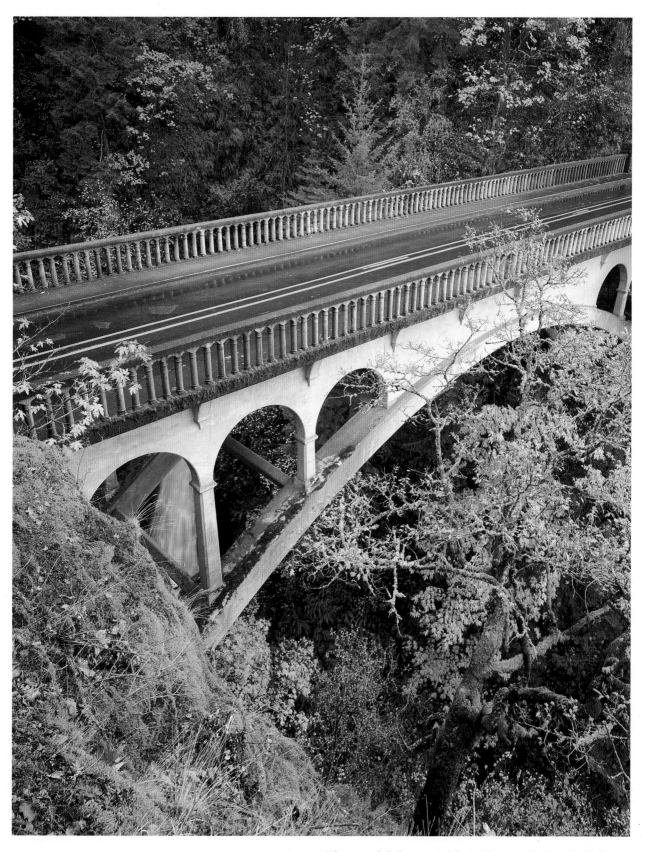

The graceful elegance of the bridges on the Scenic Highway

basalt flow. It is believed the flow completely filled the canyon but all except this promontory were swept away in the great floods that came through. Rooster Rock, on the canyon floor, is a portion that broke off and slid down. The unusual structure of Crown Point Vista House was built as a memorial to the pioneers. Inside the castle-like fortress you can buy snacks or gifts, as well as learn more about the area's history.

One of the most wonderful provisions of the Scenic Highway is the access provided to waterfalls. Latourell Falls, within Guy W. Talbot State Park, is the first of the major gorge waterfalls. This is an exceptionally pretty waterfall, designated a "plunge," a term which describes any waterfall that descends vertically from a stream, losing contact with the bedrock. A short trail leads to Upper Latourell Falls, where hikers can have the pleasure of walking behind its falling waters.

Across the river on the Washington side, Mt. Zion rises to provide its own spectacular vista of the valley. Zion is an extinct volcano. Nearer the river lies Cape Horn, so named by early voyageurs because of the difficulty it created in their passage, difficulties similar to the problems created by the Cape Horn on the tip of South America. Faint pictographs and petroglyphs can be seen at the base of the large cliff.

Back on the Oregon side, Bridal Veil Falls can be approached by car. A 110-foot long bridge crosses directly over the top of the falls. Only slightly less spectacular than Latourell, it is a "tiered" waterfall, one that descends from a series of outcroppings to produce several distinct falls that can be seen

from one vantage point. While in the Bridal Veil area, hike to Coopey Falls. You can view the falls from above by hiking 0.6 mile up Angels Rest Trail from the trailhead on the Scenic Highway. Coopey Falls drops 150 to 175 feet. A convent sits near the base of the falls.

The Multnomah Falls area is the best known since it can be seen in part from Interstate 84. All falls in this area are accessible from the Columbia Gorge Scenic Highway and there is access to many from the Multnomah Falls Rest Area (exit 31) off Interstate 84. Falls in this area include Mist Falls, Wahkeena Falls, Necktie Falls, Fairy Falls, Multnomah Falls, Dutchman Falls, and Double Falls.

Mist Falls spirals down from Mist Creek creating a soft, timeless scene that makes you feel like Indians could pad through the forest on moccasined feet any moment.

Wahkeena Falls is a stunning 242-foot tiered fall that cascades over steeply slanted rocks. Wahkeena is an Indian word said to mean "most beautiful." A large picnic area lies opposite the falls.

Necktie Falls and Fairy Falls demand short hikes. Fairy Falls is a lovely fan of water, descending in an increasing breadth of spray.

Multnomah Falls is the fourth highest waterfall in the United States. The main fall plunges 542 feet and Lower Multnomah Falls drops an additional 69 feet. There's a trail to the top and at the one-mile mark, a side trail leads to a viewpoint over Multnomah Falls. Further up the mountain lies Little Multnomah Falls, which has a descent of only ten to fifteen feet. It's worth the trek for the view. A story told in the

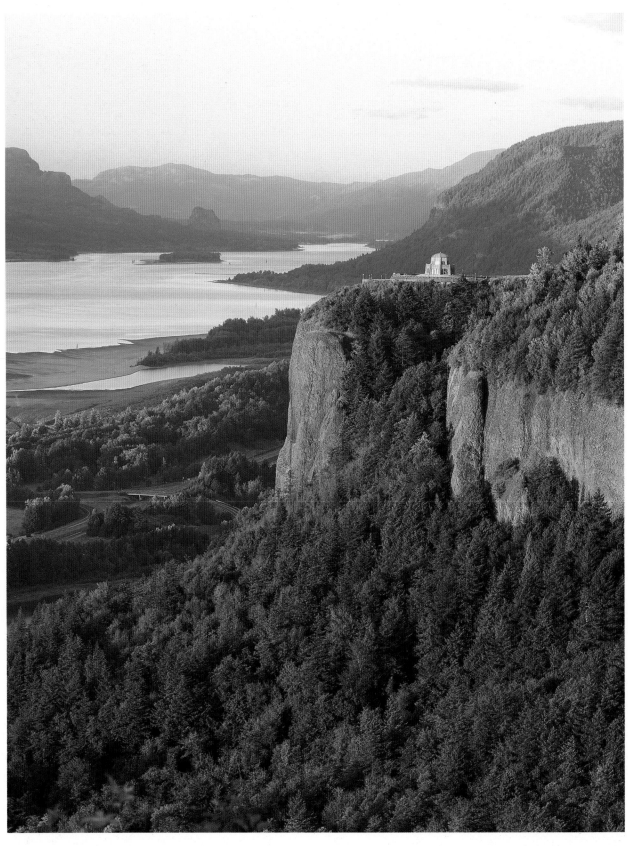

Crown Point in the warm afternoon sun

Opposite page: The Indians called it Wahkeena and it is still "Most Beautiful"

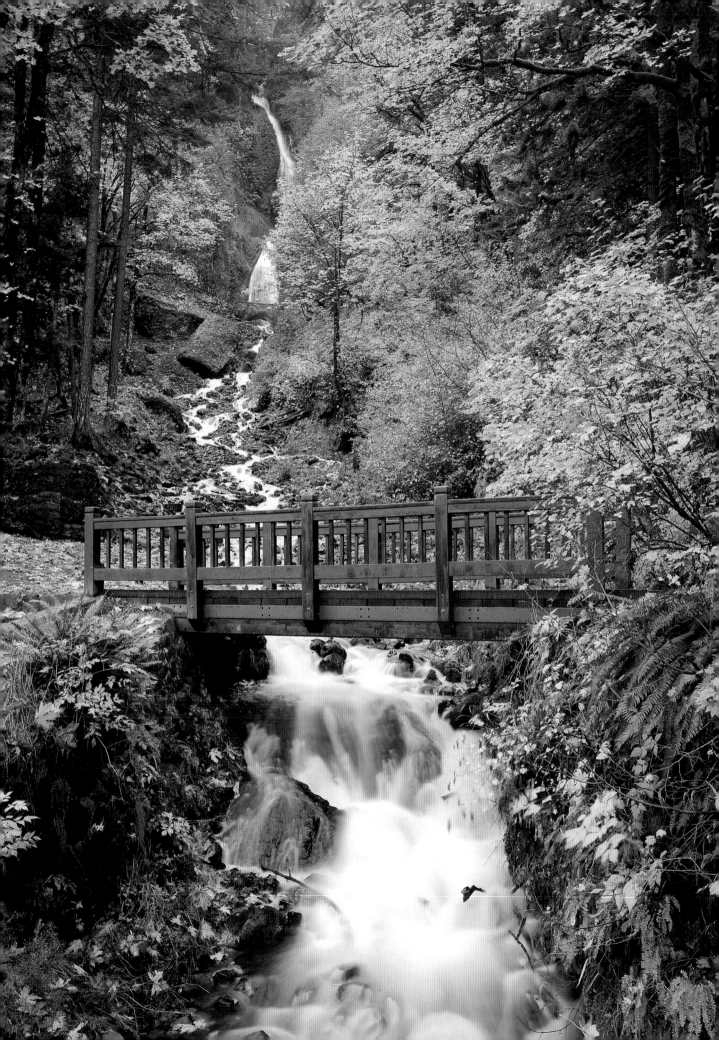

gift shop at the base of the falls goes like this:

"Many years ago, a terrible sickness came over the village of the Multnomah people and many died. An old medicine man of the tribe told the Chief of the Multnomahs that a pure and innocent maiden must go to a high cliff above the Big River and throw herself on the rocks below and the sickness would leave at once.

"The Chief did not want to ask any maiden to make the sacrifice. But, when the Chief's daughter saw the sickness on the face of her lover, she went to the high cliff and threw herself on the rocks below and the sickness went away.

"As a token of the maiden's welcome by the Great Spirit, a stream of water, silvery white, streamed over the cliff and broke into a floating mist along the face of the cliff. Even today, as you carefully watch, the maiden's face can be seen in the upper waterfall as the breeze gently rustles the watery strands of her silken hair."

The last falls within the Multnomah Falls area are Dutchman and Double Falls. Dutchman Falls is a series of three falls along Multnomah Creek. The lower and upper falls drop ten to fifteen feet, and the middle descent tumbles fifteen to twenty feet. You need to hike in to see it, so take Larch Mountain Trail #441. If you continue along the trail, you can see the spectacular Double Falls—it is a sweeping double plunge that covers a total of nearly 200 feet. Waterfall fanciers rate it a three, which means it's definately worth a stop.

Larch Mountain is easy to reach off Highway 30 just west of Crown Point. A walk of about 0.4 mile will put you at the top

of Sherrard Point. From these cliffs you can see the volcanically-shortened Mount St. Helens, the looming magnificence of Mt. Rainier, and further right, Mt. Adams. Looking east and a bit south, you can see Oregon's Mt. Hood. Threads of river are visible below. There's a Larch Mountain on the Washington side, too, and, like its counterpart, it provides a view.

As you leave the Multnomah Falls area, you enter the Oneonta and Horsetail Drainages. Oneonta Gorge is a narrow fissure in the rocks where Oneonta Creek splashes through. It's a cool, green, unique botanical area and the hike is worthwhile especially if you plan on continuing along Oneonta Trail and Horsetail Falls Trail. A fossil forest lies between the lava flows.

The next stop on Oneonta Trail is Triple Falls and it receives a five-star rating among waterfall fanciers. Here, three falls bubble at once over basaltic outcroppings to plunge for over 100 feet.

Horsetail Falls spread out like, what else? A horse's tail. It, too, is stunning. Horsetail Falls are so close to the Scenic Highway that a fine mist often sprays across the road. For an unusual experience, take the trail that leads behind the falls. Ponytail Falls, a short distance away, is only less majestic because of the company it keeps. It deserves the extra trek.

East of Horsetail Falls lies the entrance to Ainsworth Park. Gigantic basaltic cliffs and formations loom over Ainsworth Park. One of the formations is a monolith known as St. Peter's Dome. Rock climbers challenged it for many years before the summit was reached in 1940. Rock of Ages is another guardian here.

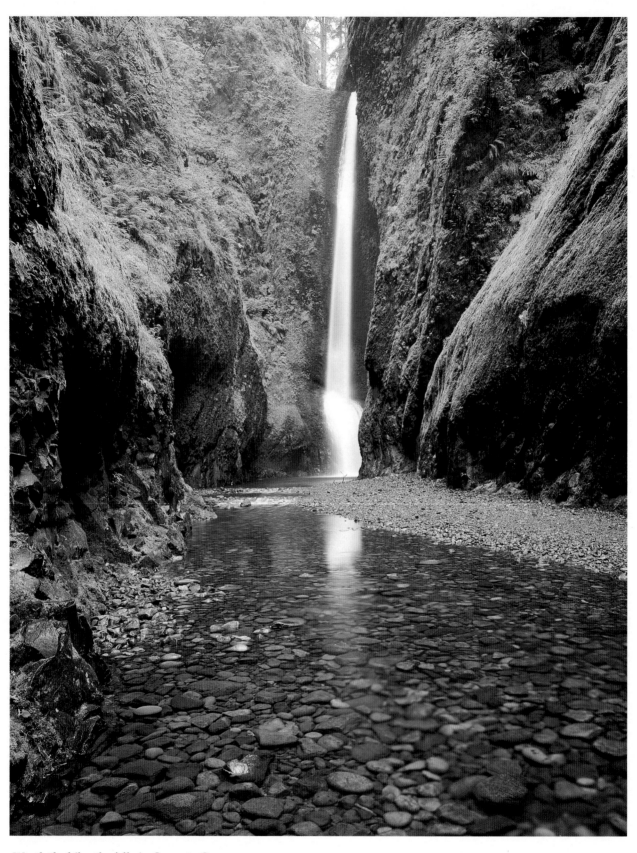

Worth the hike, the falls in Oneonta Gorge

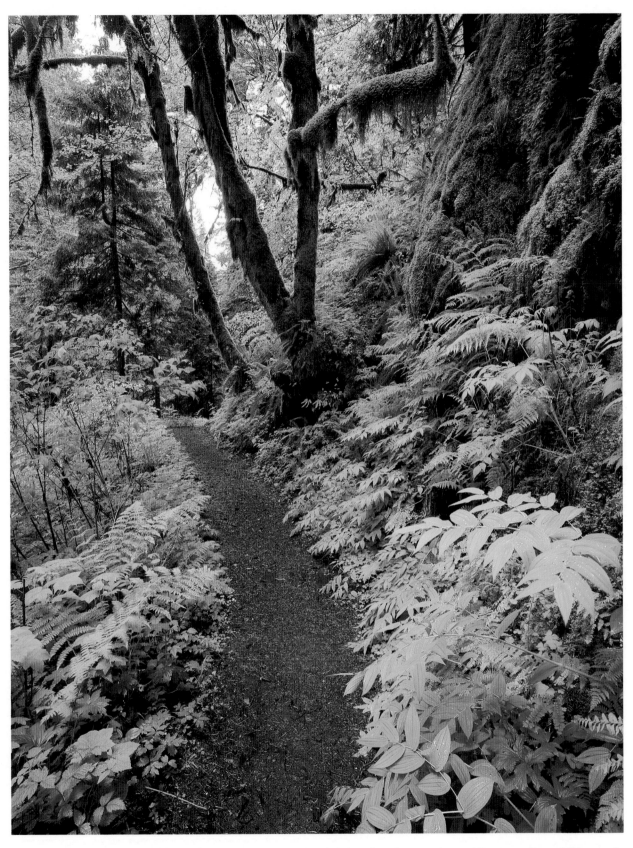

The verdant beauty of one of the many Gorge hiking trails

The John B. Yeon State Park is adjacent to the east end of the Columbia Gorge Scenic Highway, just before it returns to Interstate 84. It's a beautiful park and there are several waterfalls within its boundaries. The most outstanding is Elowah Falls, a five-star waterfall like Multnomah. Unlike Multnomah Falls, Elowah can only be reached by climbing a trail. The trail is moderately steep, but the reward is worth every upward footstep.

Turn off at Eagle Creek Park if you're interested in a refreshing hike that can provide unparalleled scenery. The trail takes you past several waterfalls within the Eagle Creek Drainage. There are eight falls along Eagle Creek Trail. The largest and most stunning are Metlako Falls and Punch Bowl Falls. Metlako was named in 1915 for the legendary Indian goddess of the salmon by a committee of the Mazamas, an outdoor recreation group. Punchbowl Falls is a smaller fall in comparison to many of the others in the gorge, but rates up there as one of the prettiest. The descent of the falls is short, only about fifteen feet, but the pool formed beneath lies within the realm of fairytales. Few would argue that Eagle Creek Trail is one of the most popular and gorgeous hiking trails in the Pacific Northwest.

Traveling any of the hundreds of fern-laden paths causes one to reflect upon earlier times and the effect of the land upon the people who lived here.

The first people of record along The Gorge were a combination of tribes lumped together under the name Chinook. From up and down the river there was an annual migration of tribes to Celilo Falls. Here the Chinook Indians

gathered to trade with Indians from all of Western America in what has been called "the trading mart of the Columbia." From the plains, the Rocky Mountains, the southwest, and Minnesota they traveled to trade for such things as fish, dried oysters and clams, berries and roots. The Chinooks also traded wappato, which grew in the water and was harvested by women who hung their legs over the sides of canoes and scooped the bulbous root from underwater with their toes.

Most marketable was the salmon that was dried on racks then pounded into powder between stones before being pressed and packed in bales of grass matting. The bales were then covered with dried fish skin and stacked into packages which weighed between ninety and one hundred pounds and would keep for several years. A few pinches of salmon powder was all it took to flavor soup or other foods, so the Indians received good barter for these bales.

The Indian gatherings offered more than an opportunity to trade, for the fun-loving Indians cherished this time for enjoying races and various games of chance. Often tribal chiefs would each bring their best horse for racing and the other Indians would place bets.

Many of the artifacts that could portray more about the fascinating people who inhabited The Gorge are now buried under the water that was captured by dams erected during the mid-Twentieth century.

Only a few descendents of the Columbia River Gorge tribes remain to pass on the legends. Without the diligence of many, the treasures of ancient man and of nature may not survive in this great area. Those who love The Gorge, its habitat and

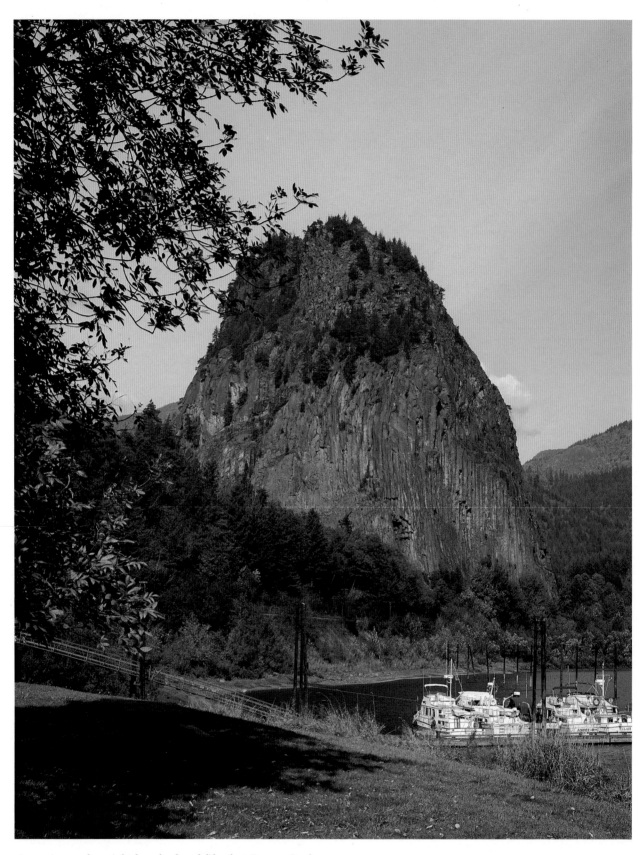

A scenic wonder, eight hundred and fifty foot Beacon Rock

history, continually struggle to maintain its environment. Beacon Rock and Beacon Rock State Park sit on the Washington side of the river.

Beacon Rock is the dominant feature on the north shore of the Columbia and is, in fact, the largest monolith in the nation (240 feet higher than Devil's Tower, Wyoming). The rock is the leftover center of a volcanic plug, with the original surrounding cone eroded away.

Captain Clark named the rock in 1805 and in 1915 Henry J. Biddle began building a trail to the top. Biddle said his sole purpose in purchasing the rock was to build the trail. For the enormous sum of $10,000 a path was finally built. Stairs notched into the seventeen-acre rock make the 4,500 feet climb a fairly easy walk for today's explorers, though the remarkable ascent gains about a foot in altitude for every five feet walked.

Like many other landmarks in the Gorge, there is an Indian tale to match.

"Wehatpolitan was the beautiful daughter of the principal Indian chief in the area. As she matured into young womanhood, she fell in love with a young chief of a neighboring tribe who also loved her. The young chief sent a messenger seeking the girl in marriage but the stern father would not consent to the request. This great love did not end here and the two lovers met clandestinely and were secretly married. The father was unaware this had happened, so he gave Wehatpolitan to a chief whom he favored. The latter kept silent and constant watch of the girl and one night he saw her

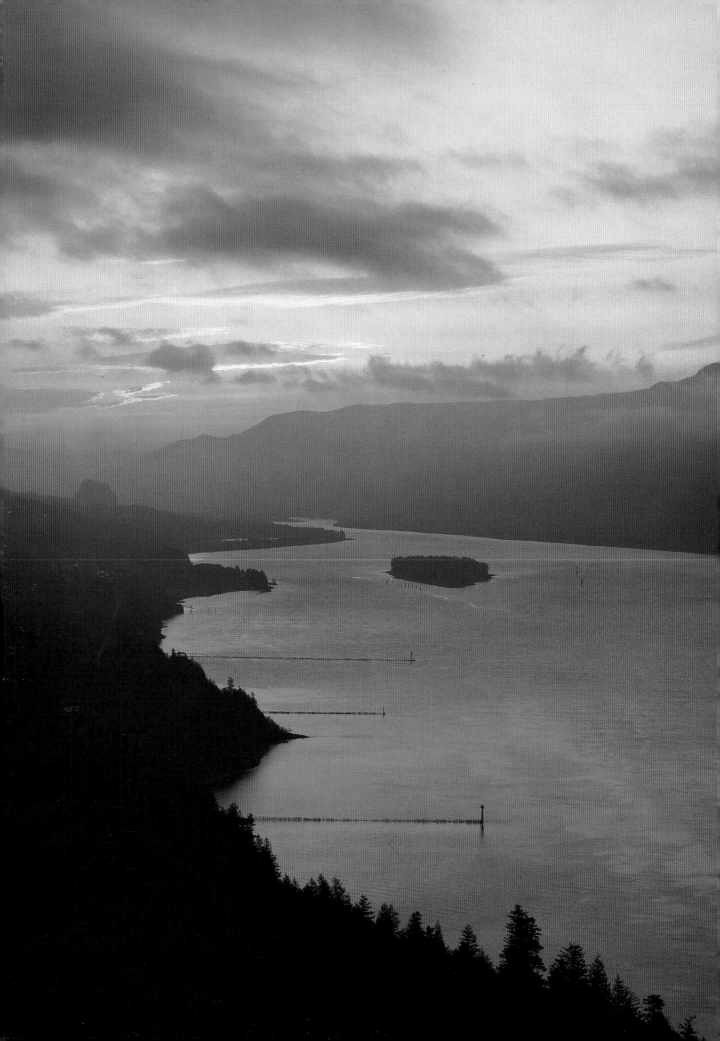

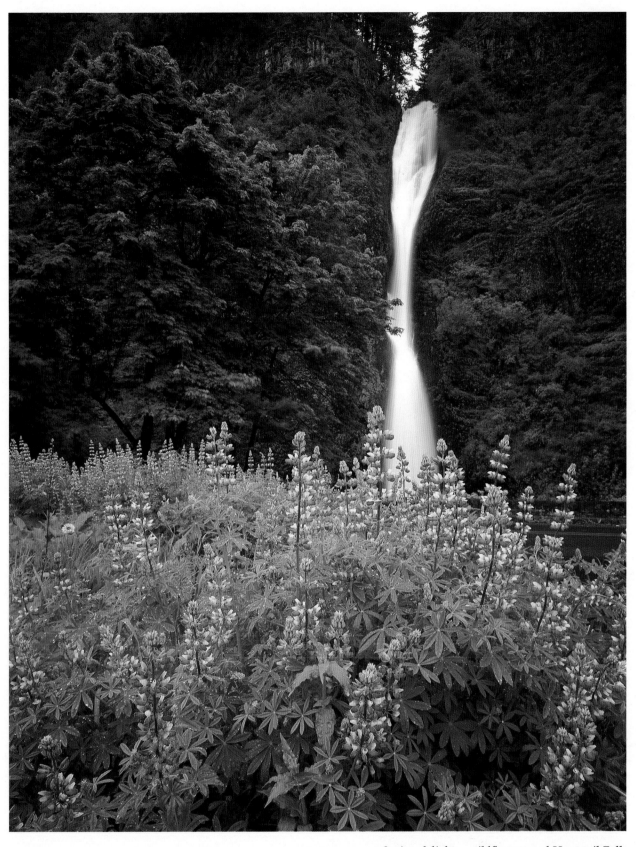

Spring delight—wildflowers and Horsetail Falls

Opposite page: The splendor of a Gorge sunrise

stealing away and he followed her and watched her meet Penpen and fall into his arms. He returned telling the father what he had seen.

"The big chief then sent word to Penpen and the girl that all was forgiven and if they would return to her people, Penpen and Wehatpolitan would be rightfully wed. Rejoicing at the good news and happy that Wehatpolitan could see her people, Penpen hastened to see the father, but no sooner than he arrived, he was seized and executed.

"Not long after this, the heartbroken girl gave birth to a child. The father decreed the child must share its father's fate. On learning this, Wehatpolitan took her baby in her arms and disappeared. The stern chief had his executioners search in vain for the child which they could not find. In a few days the Indians heard wailings from the top of Che che optin (Beacon Rock), and they soon discovered that the poor girl had climbed with her child to the inaccessible top of this monolith. The old chief, repenting of his harsh actions, called out to his daughter to come down and he would forgive her. But fearing treachery, she paid no heed, and the wailing continued. Overcome with grief, the remorseful chief offered all kinds of rewards to anyone who would climb the rock and save his daughter's life, and that of the child. Many tried but none could succeed. After a few days, the half-crazed father decided to climb the rock. He was never seen again. The Indians thought that on reaching the lifeless bodies of his daughter and grandson he just had lain down beside them and died. Even yet the heart-breaking wailings can be heard coming off the rock when the wind blows, the wailing voice of the

unhappy Wehatpolitan spirit."

Adjacent to the state park is an historic Indian village site called Wahclellah. It was once one of the major villages on the Columbia. Captain Clark noted "fourteen houses remain entire, nine others appear to have been lately removed, and the traces of ten or twelve others of ancient date were to be seen at the rear of their present village." It is most likely the occupants were in the process of moving to The Cascades and the Oregon City Falls for the fishing season. They would have packed their boards with them to erect their summer houses.

Across the river sits the Warrendale site where Frank Warren constructed a salmon cannery in 1876. This was before the dams, so the water here was swift and fishwheels were used to capture the fish.

Hamilton Mountain lies northeast of Beacon Rock. It was capped by basalt flows in an ancient side valley. Table Mountain and Greenleaf Peak are neighbors to Hamilton. Greenleaf Peak is the highest point in the Gorge on the north side of the Columbia River. Table Mountain and Greenleaf Peak are the sides, and the Red Bluffs the face, of the Great Cascade Slide of some 750-800 years ago. The slide moved five billion cubic yards of material and changed the course of the Columbia River. Evidence of Indian rites is found at the base of the Red Bluffs.

An exciting panorama can be had from the top of Table Mountain. In addition, the mountain's variety of exposures, terrain, and extreme weather conditions have resulted in an interesting assemblage of plant species not seen elsewhere in

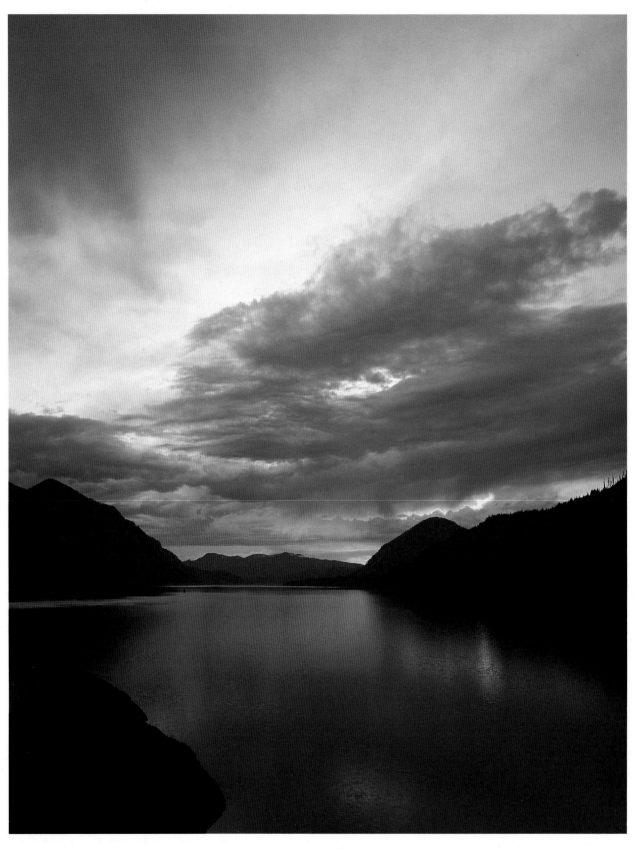

The pastel beauty of a Gorge sunset

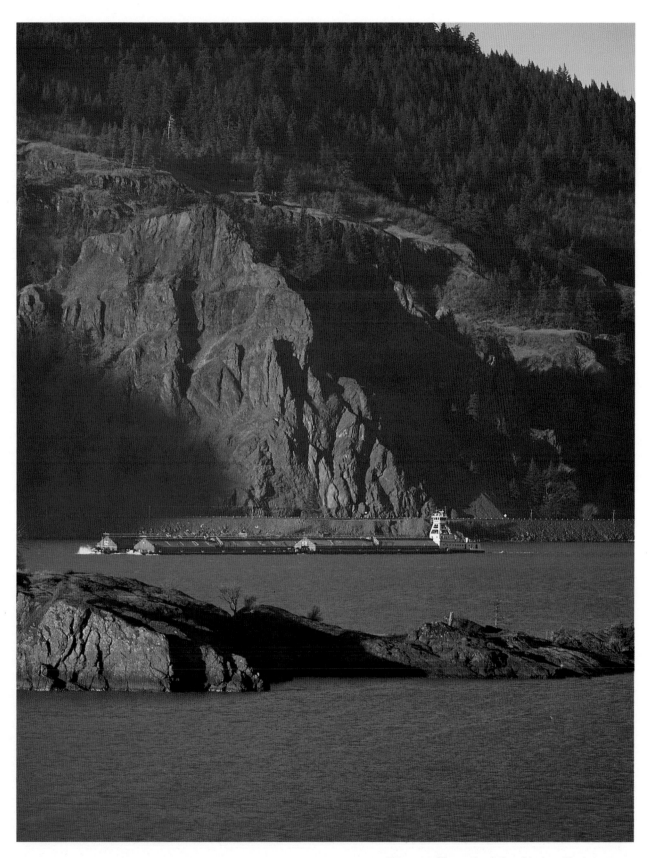

Barge traffic on the Columbia is still picturesque

the immediate vicinity of the Columbia Gorge. The summit area closely resembles the sub-aline zone. The area is considered to be very significant botanically. Many of the species here are normally found at much higher elevations. Several plants peculiar only to the Columbia River Gorge can be discovered in the cliff's rocky and shaded areas.

A short distance away is Moffetts Hot Springs, a natural volcanic hot springs area that is the local historic site of a hot springs and lodge facilities. It lies directly across the river from the Bonneville Lock and Dam.

The U.S. Army Corp of Engineers has turned Bonneville Lock and Dam into a first-rate tourist park. This dam, constructed in the 1930's, was the first federal hydroelectric dam on the Columbia River. It is the furthest point for tidal water fluctuations of the Pacific Ocean. The underground visitors center provides a view of salmon and other fish migrating upstream via the fish ladders. The nearby Oregon State Fish Hatchery holds thousands of fingerling salmon. Along with a trout and sturgeon pond that give an interesting view of many fine specimens, there are displays which provide a detailed history of Oregon fish.

Remember on this drive to take the exit one mile east of the Bonneville Dam. At milepost 41, the Eagle Creek exit leads to one of the prettiest areas in the gorge and to the aforementioned Eagle Creek hiking trail. After crossing the lovely Eagle Creek Bridge, a left turn puts you in the parking lot at the foot of a small hill. Overlook Park sits atop the hill, and there's a memorable picnic area and a shelter that was built to house some of the flora species found in the Eagle Creek area. Have a

picnic before you hit the trailhead just a mile or so after the bridge. A 1.5 mile hike takes you to Metlako Falls or two miles up is the gorgeous PunchBowl Falls, an area photographers love. If your walking legs are strong, travel another eleven miles or so to see pretty Wahtum Lake.

East of Moffetts Hot Springs and near Wauna Lake lies an Indian Burial Site. The diaries of Lewis and Clark proclaimed:

"In a verry thick part of the woods is 8 vaults which appeared closely covered and highly deckerated with orniments. In several of those vaults the dead bodies were raped up verry securely in Skins tied with cords, laid on a mat, and some of those vaults had as many as 4 bodies laying on top of each other. I also observed the remains of Vaults rotted entirely into the ground and covered with moss. This must bee the burying place of many ages for the inhabitants of those rapids." Above the vaults was a village with "verry large houses bilt in a diferent form from any I had seen, and lately abandoned."

One of the loveliest spots to relax is the Columbia River Gorge Hotel. This magnificent old hotel enjoys a world-wide reputation. Built in 1921, it was the brainchild of millionaire Simon Benson. Perhaps even more beautiful today than when built, the hotel perches on a cliff, high above the river. Stunningly manicured park-like grounds surround the hotel and four-star Wah-Gwin-Gwin Falls tumbles over boulders behind the hotel before dropping from sight. Since each room was unique, the service superb, and the quality of meals renowned, the Columbia River Gorge Hotel drew people from

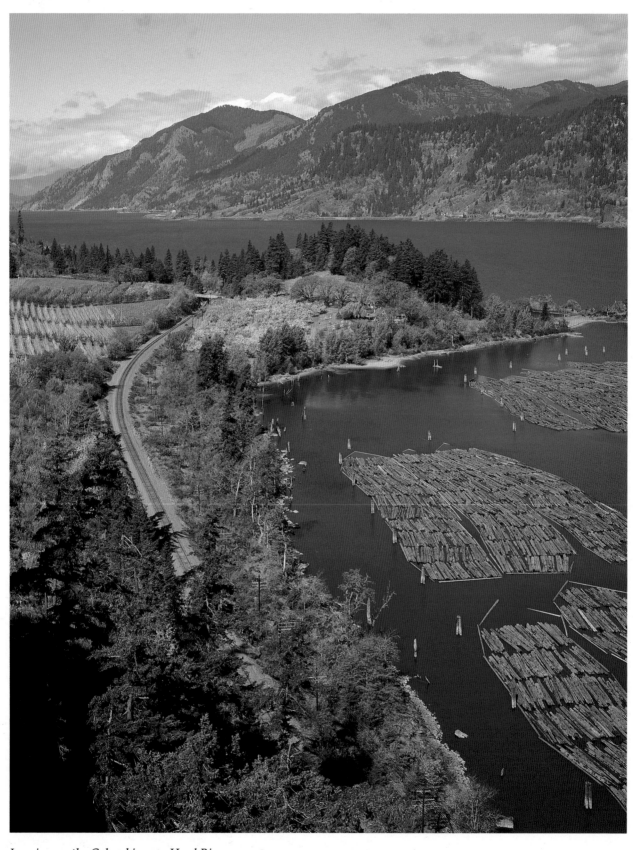

Logging on the Columbia near Hood River

Opposite page: Delicate ferns and beautiful Moffett Creek Falls near Bonneville

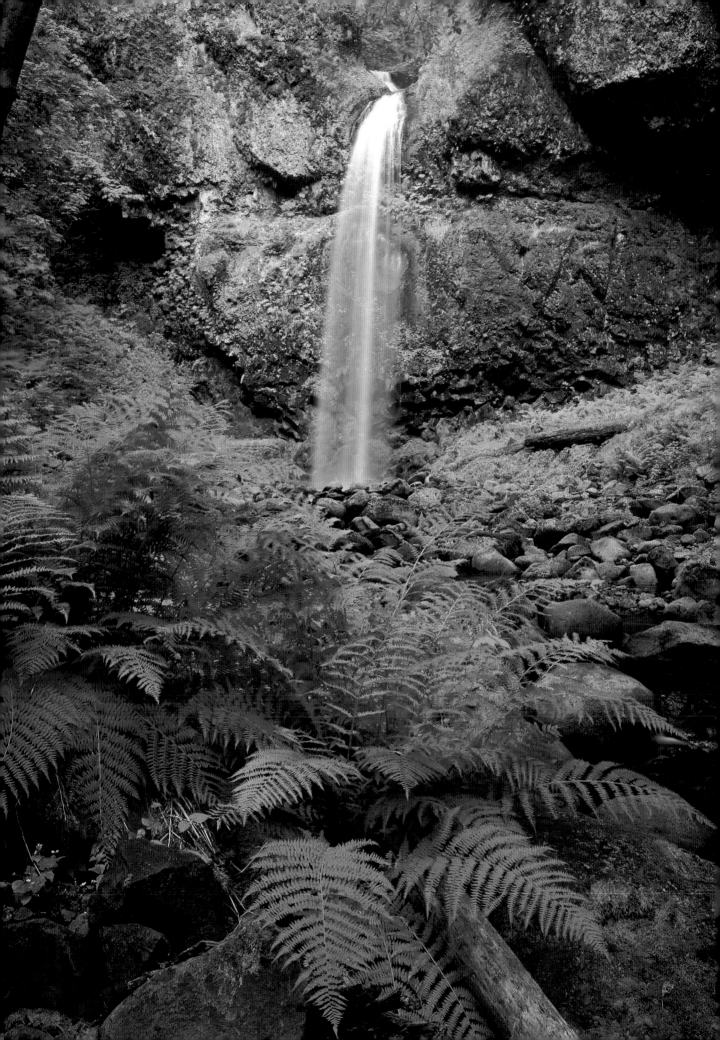

all over the world. The hotel remains a gentle, graceful place, and fortunately, its continued fame has not caused it to be overpriced. Even those who are not movie stars or political royalty can afford to enjoy the pleasures of a room restored to its 1920 grandeur.

The next significant stop downriver is the current day Bridge of the Gods. A magnificent stucture, it is cited in the National Register of Historic Places. Nearby picnic spots make appropriate stopping places.

Cascade Locks, just off Interstate 84, is an historic little community where the locks are now designated as a national Historic Site. Visitors will find a park, a marina, and a museum. The Cascade Locks Historical Museum, located in the Cascade Locks Port Marine Park, makes for an interesting stop. On display is the first steam train built on the Pacific Coast, the Oregon Pony. The remains of the original locks through the cascades are nearby. Cascade Locks Marina Park is the summer home of the Columbia Gorge Sternwheeler, an authentic reproduction of an old-time river boat. Sternwheeler cruises are offered daily during the summer season, and there are a variety of dinner cruises and special voyages.

In the Bingen-White Salmon area of Washington there is another interesting Indian village. Here, many of the lodgings were semi-subterranian. The Indians dug pits in the ground and then roofed them over with poles and covered the poles with grass and earth. They left a hole in the center of the roof for access and to serve as a smoke hole.

Slightly upriver from Bingen-White Salmon is an area of

nearly 2,000 acres (from Coyote Wall to Major Creek) that contains twelve plant species on the Washington list of endangered, threatened, or sensitive plants. This is a rich botanical area for anyone interested in plants.

Traveling west down the highway from Cascade Locks, two waterfalls can be glimpsed. Lancaster Falls is named after the consulting engineer who built the Columbia River Scenic Highway, the other waterfall, although technically named Warren Creek Falls, has acquired the name Hole-In-The-Wall-Falls. To eliminate rockslides when Warren Creek filled its banks, a diversion tunnel was built through the cliff. This caused the falls to gush from the middle of the cliff, seemingly spilling from sheer rock.

Far back on the Oregon side, one passes Mt. Defiance, the highest point on the Columbia River Gorge. Shellrock Mountain is close by and is a sister volcanic dome to Wind Mountain on the Washington side of the Columbia River. Tracings of the pioneers' wagon route can still be seen above Washington Highway 14 near Wind Mountain.

Travelers on I-84 will envision images of pioneer hardship when they come to Starvation Creek Park, but the name is misleading for no one is known to have starved here. The name derived from an incident in 1884 just after the railroad was completed. In December of that year two trains were snowbound and it's said men on skis had to pack food in from Hood River to feed the passengers. It's also said the railroad offered the passengers three dollars per day to shovel snow. It isn't hard to put your imagination to work if you've traveled

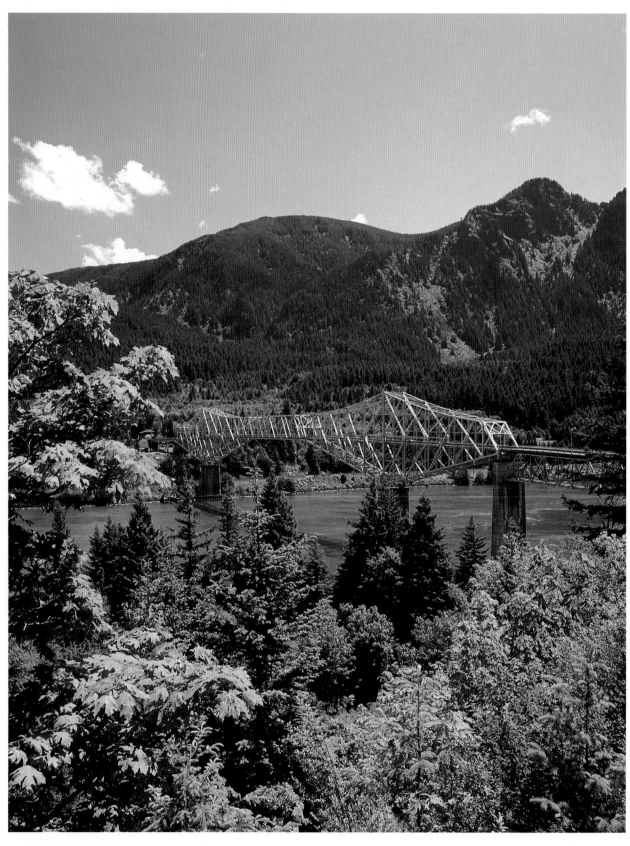

The Bridge of the Gods

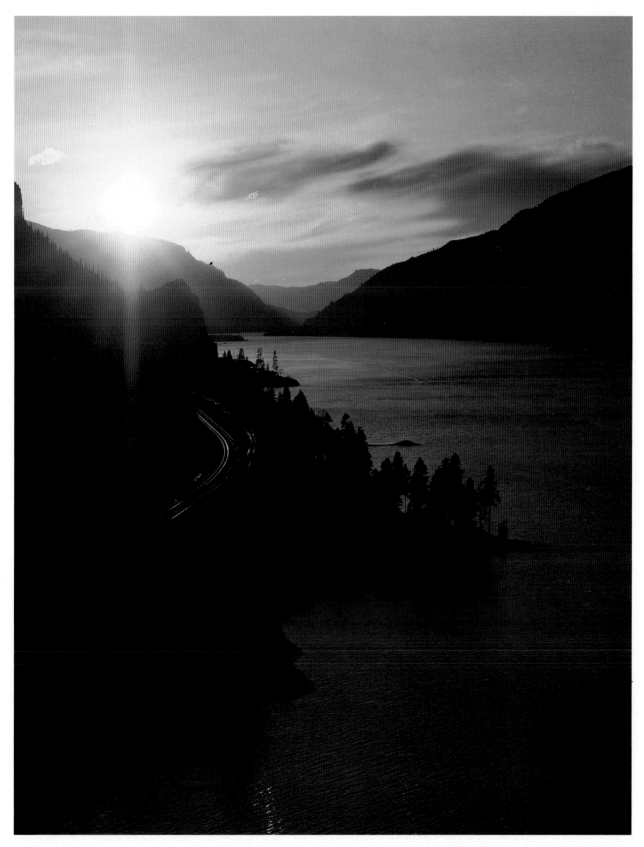

A golden Gorge sunset from Mitchell Point

through these mountains in December while the snowplows are working—an early traveler might have made a lot of money shoveling snow.

Starvation Creek Falls is a spectacular waterfall you won't want to pass. It is within short walking distance of the picnic area.

Further downriver on the Washington side near Little White Salmon River is the old Broughton Flume, a lumber flume constructed in the 1920's. It is believed to be the last operating flume of its type in the United States. The Little White Salmon River is one of the rare unaltered rivers. Close by, there's a fishing and recreational area and an estuary known as Drano Lake. Nearby, Drano Lake Bluff offers a 1,000 foot vantage point over the river. An added attraction here is a lovely stand of old-growth Douglas-fir.

Crossing back to the Oregon side of the river is the community of Hood River, a town long synonymous in the minds of Oregonians with apples, pears, and cherries. In the past couple of decades it has also developed a reputation for producing some of the most mouthwatering watermelons in the country. Produce from the prolific Hood River Valley is shipped all over the world. Like The Dalles, Hood River is also gaining praise from the windsurfing crowd. One of the most popular sailing sites in the gorge is the sailpark at the Hood River Port Marina Park. World windsurfing competitions are often held here. Lessons are available, but it's just as much fun (more to those who aren't so athletic!) to watch the sailboarders challenging the wind and the waves.

Youngsters and oldsters will enjoy the recently restored Mt.

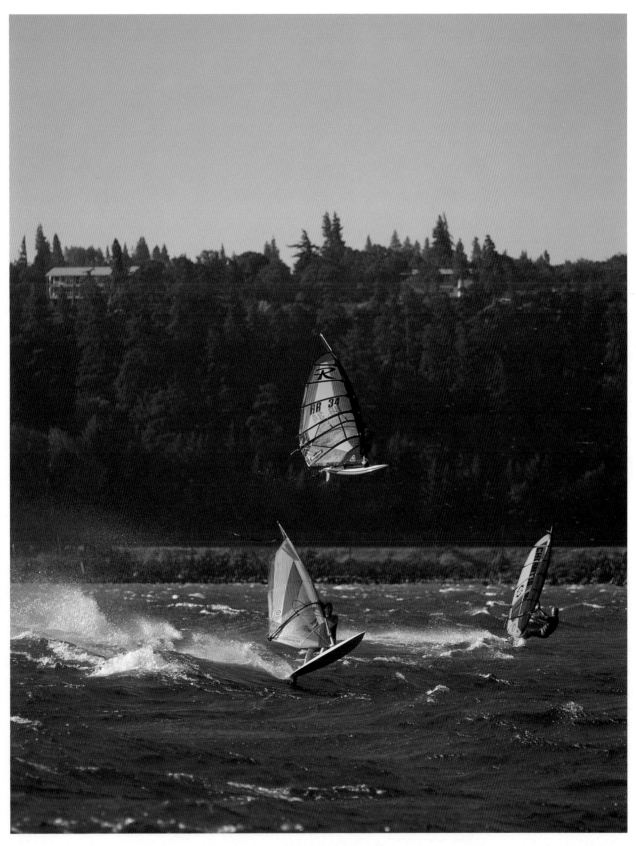

The Windsurfing Capital of the World, the Gorge near Hood River

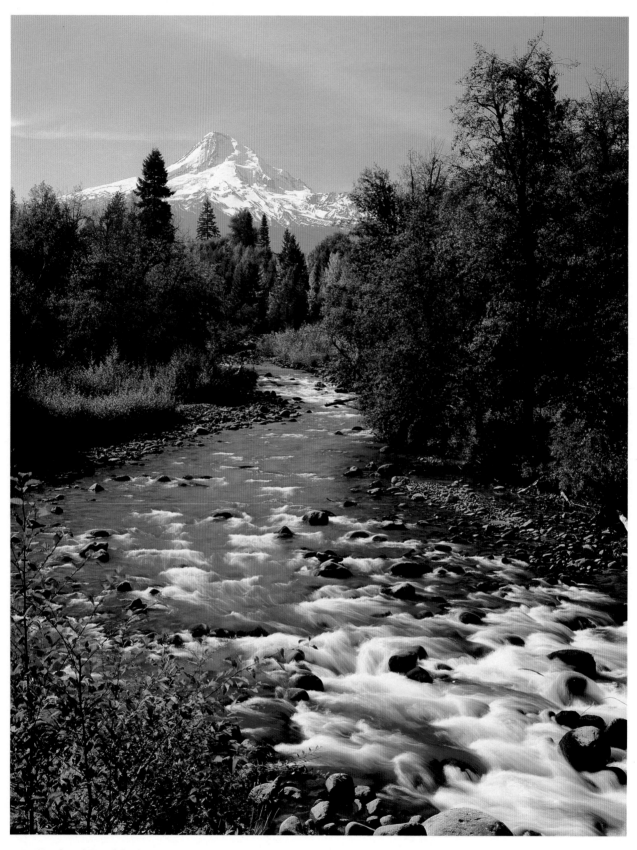

Mt. Hood and Hood River

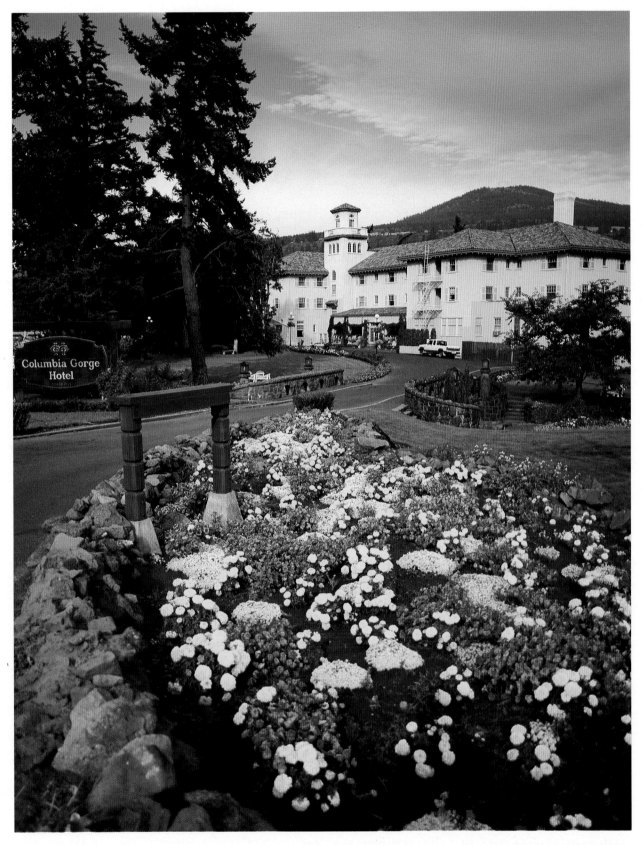

Historic and beautiful, the Columbia Gorge Hotel near Hood River

Following pages: An overview of the Gorge looking east

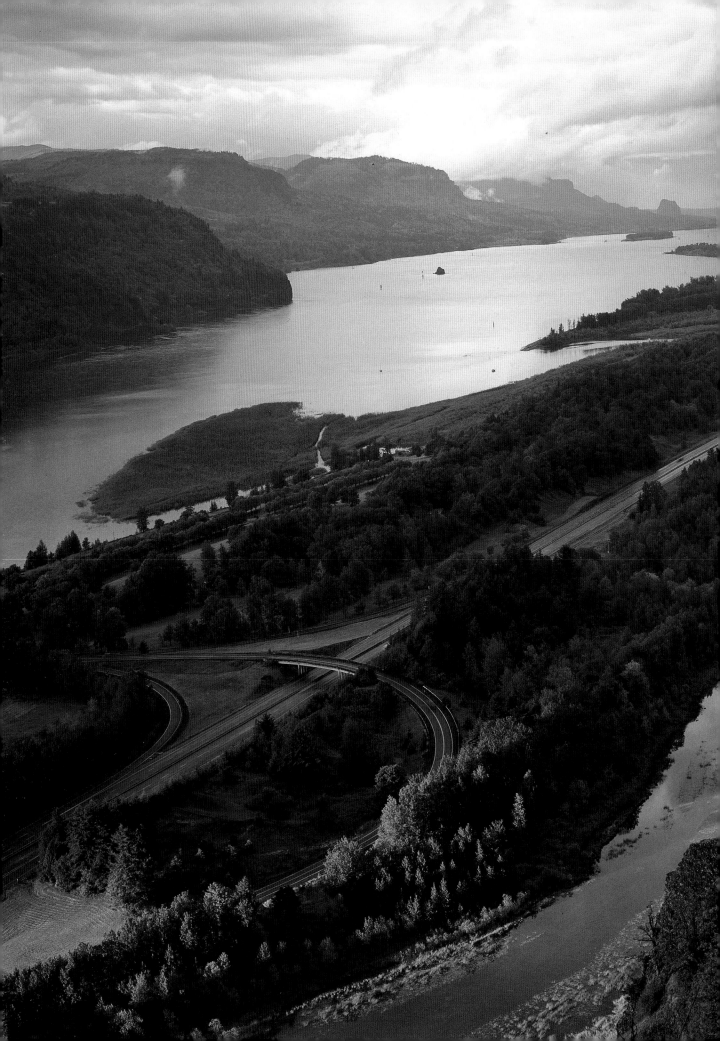

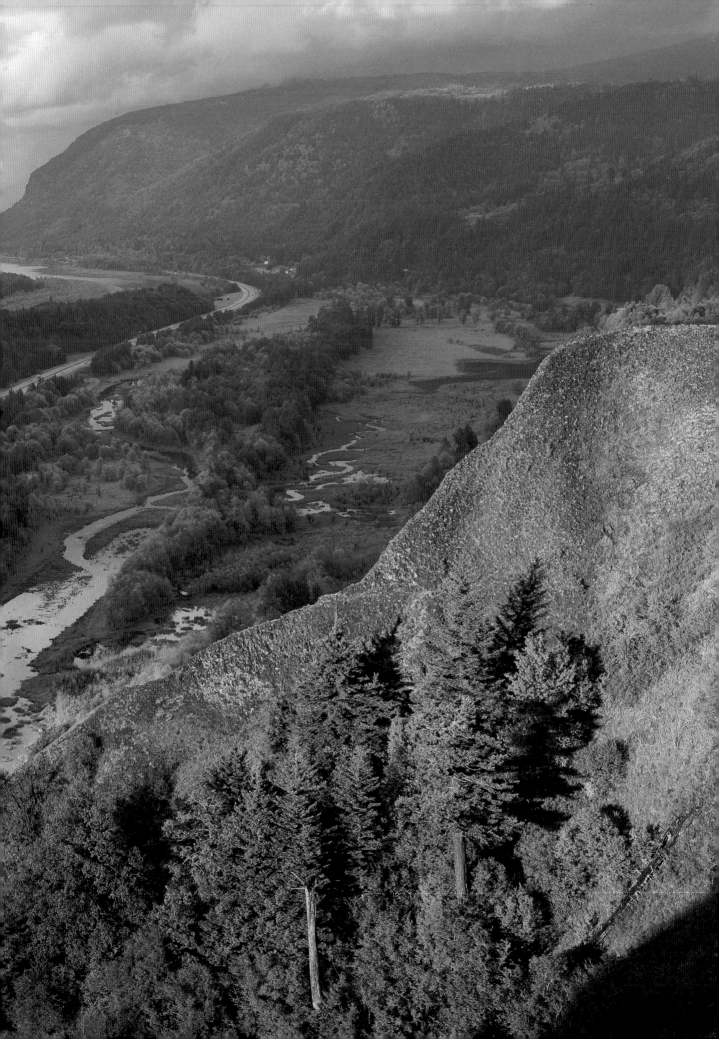

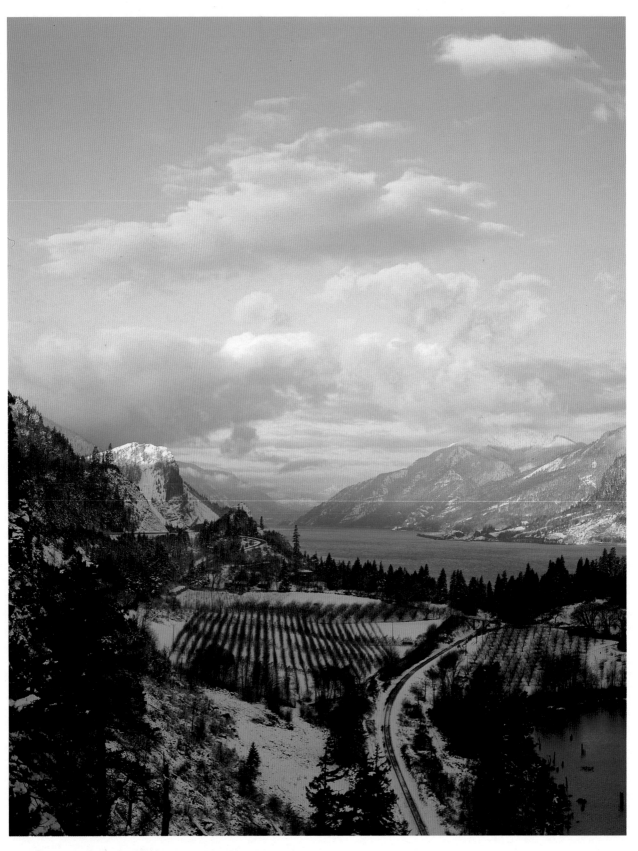

A light snow at sunrise looking west near Starvation Point

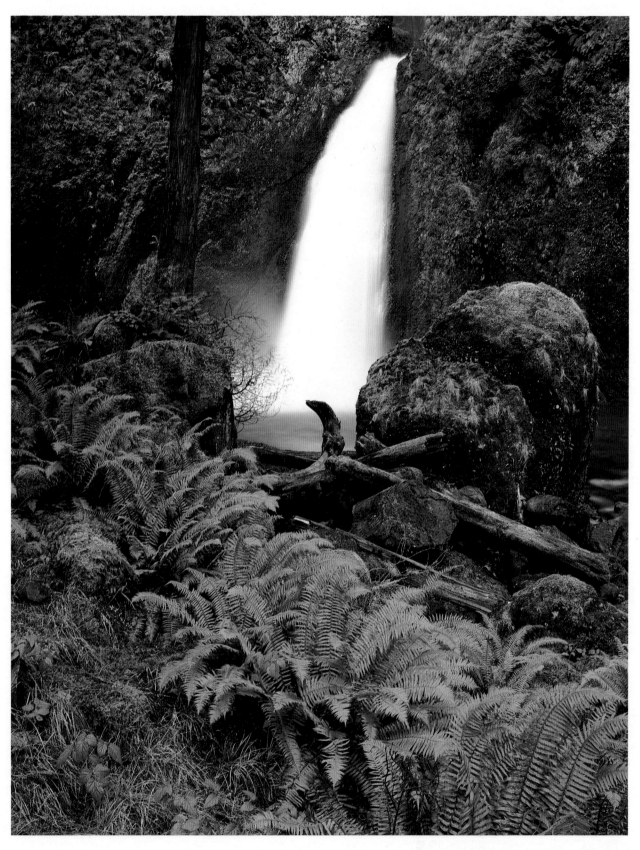

Tanner Creek Falls near Bonneville Dam

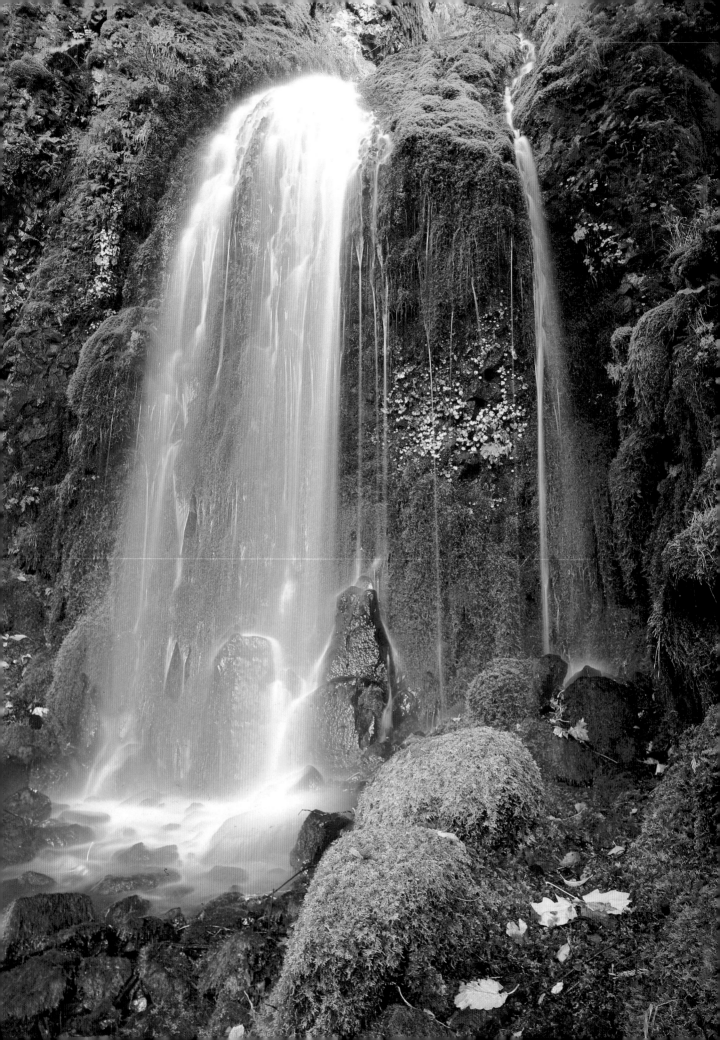

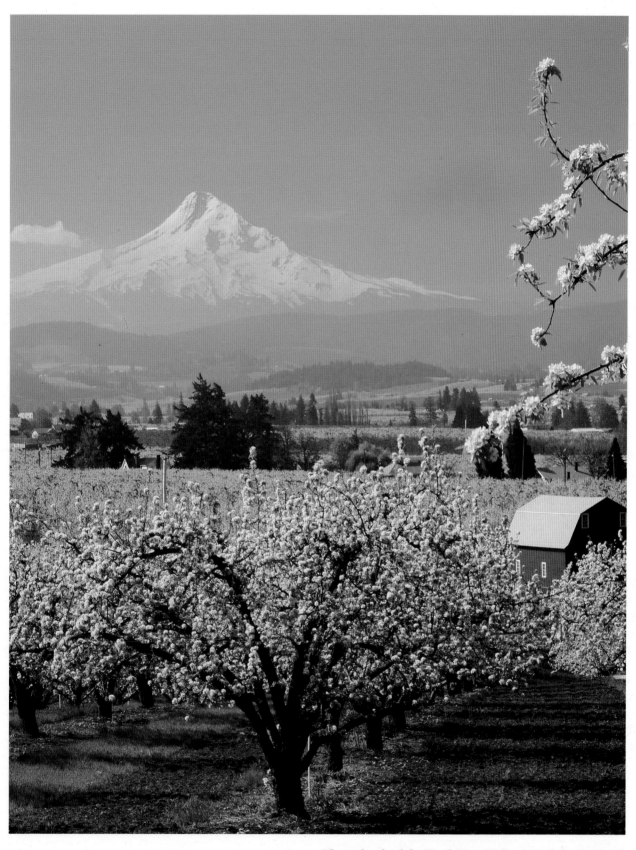

The orchards of the Hood River Valley just above the Gorge

Opposite page: An unnamed falls near Starvation Creek

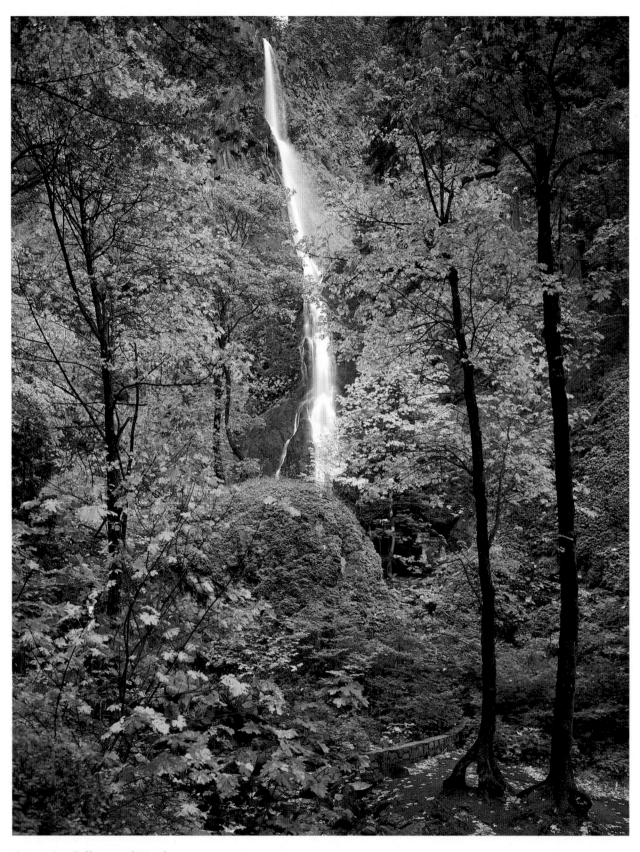

Starvation Falls east of Wyeth

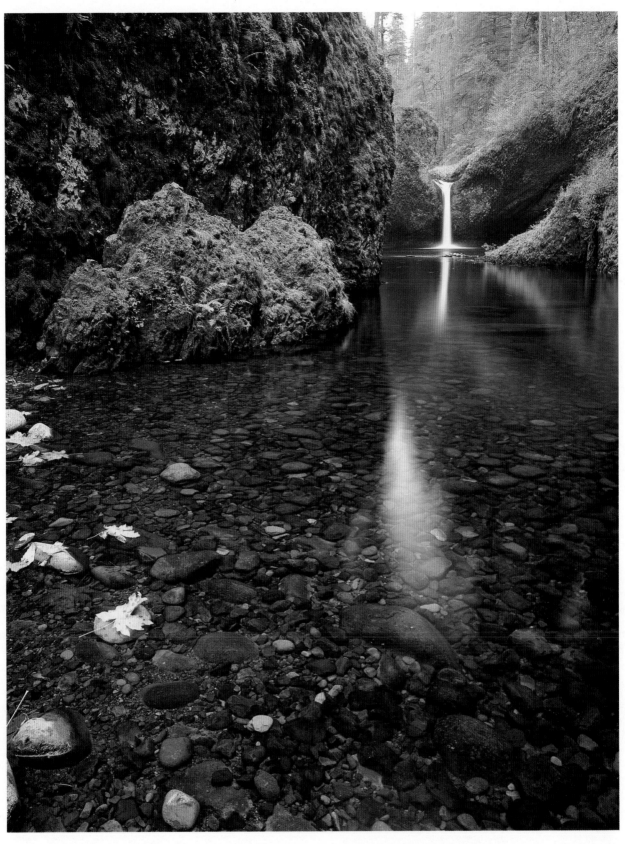

The absolute beauty of Punchbowl Falls on Eagle Creek

Following pages: Predawn beauty of Crown Point and the Gorge looking east

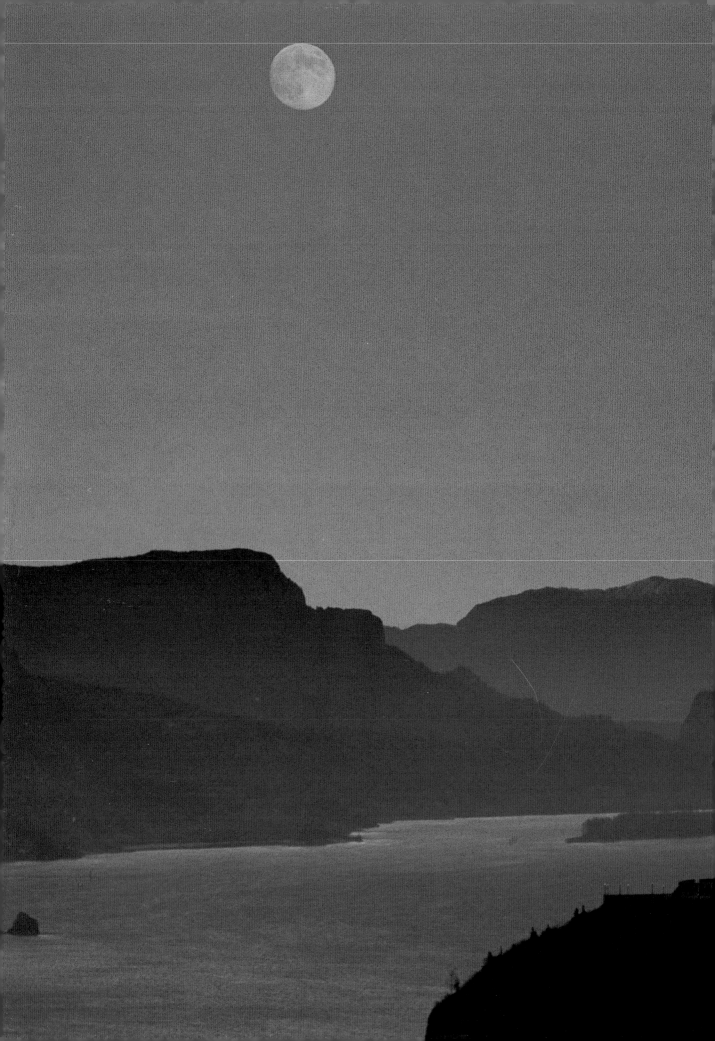

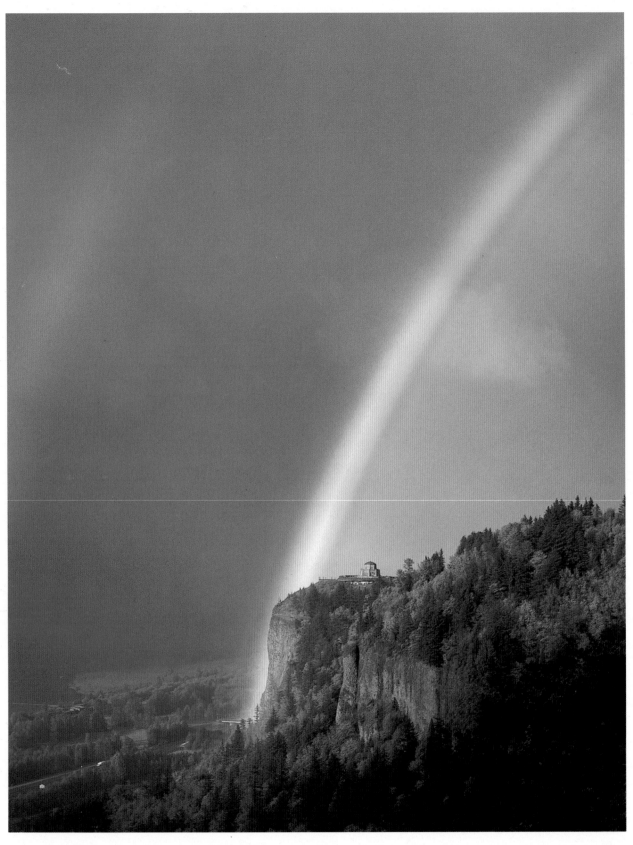

A classic double rainbow shines on Crown Point

Opposite page: Sparkling Ferry Falls against a spring green backdrop

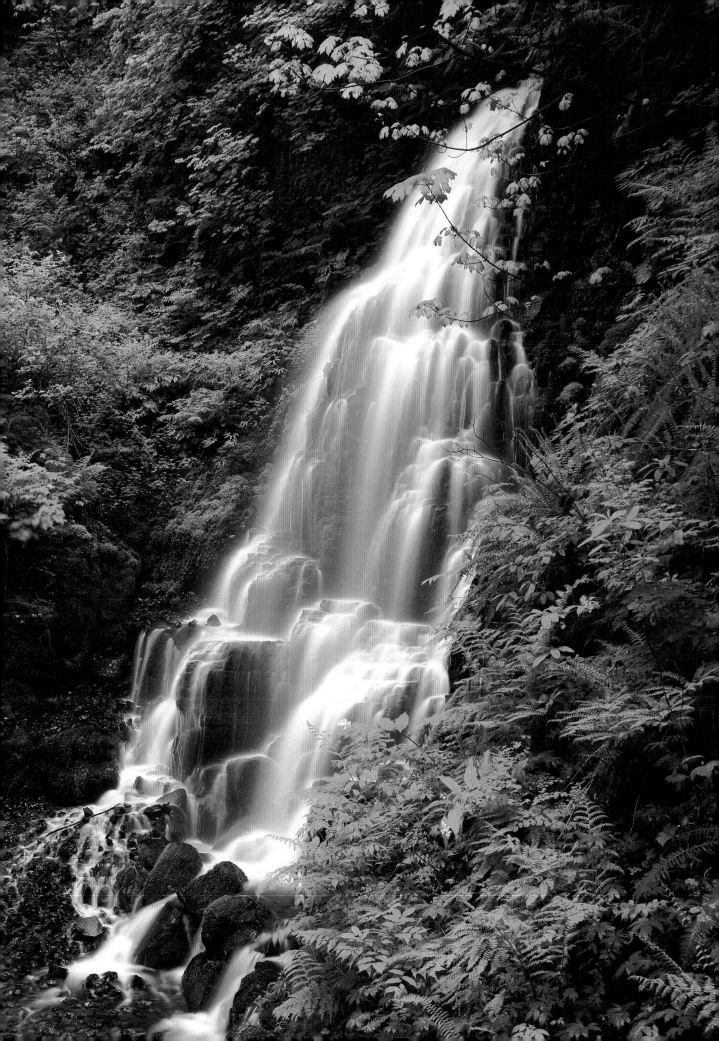

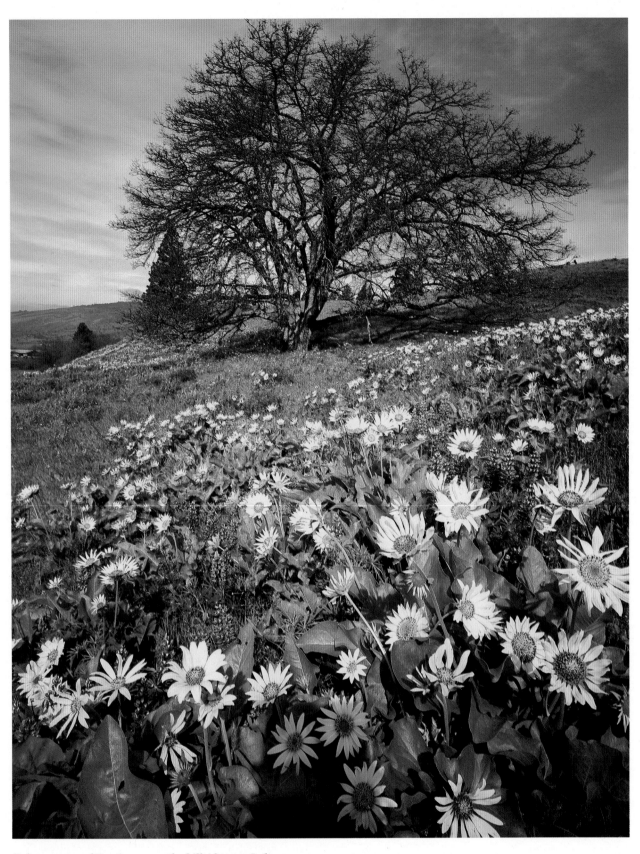

Balsamroot and Lupine cover the hillside near Lyle

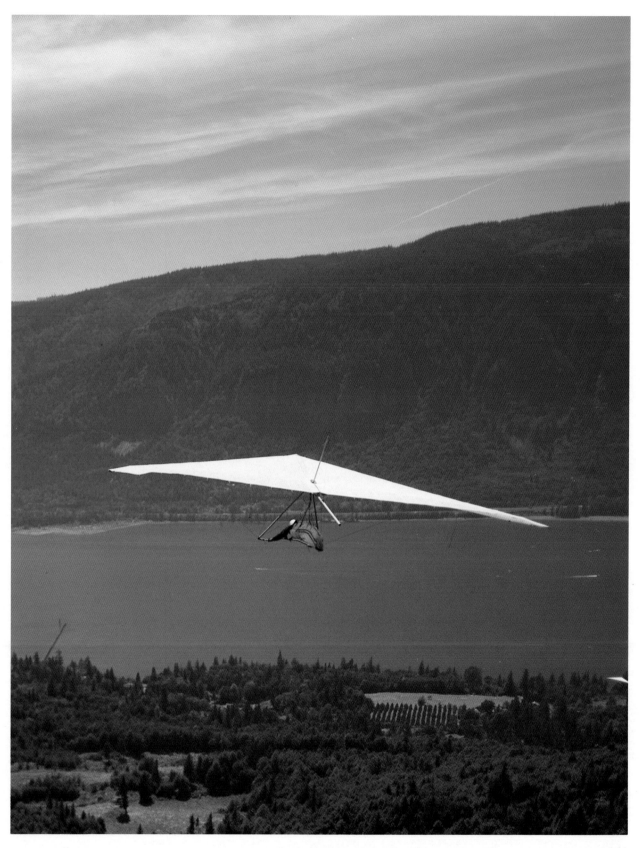

A Washington Hang Glider gets a spectacular view of the Gorge

Hood Railroad. This railroad features old-style cars and provides riders with scenic trips through the Hood River Valley. The train still keeps to the tradition of picking up cars of fruit and lumber.

The Hood River Museum gives visitors a chance to learn about Indians, explorers, pioneers, native plants, the fruit and timber industry, mountain climbing, and more. The Hood River Visitors Center helps flesh out knowledge of the local area.

Downtown Hood River holds interesting shops and historic buildings. The city traces its formal history back to its platting in 1881. A pleasant day-trip can be had by taking the Mt. Hood Loop that circles through Hood River. The Loop includes the Columbia River Gorge, Hood River Valley, Mt. Hood and Gresham.

Another scenic drive lies up Highway 35 to Cooper Spur Road, where you then follow the forest signs to Cloud Cap. Although now closed to the public, the historic Cloud Cap Inn, built in 1891, was one of the earliest tourist attractions in the Northwest. The old building, the majestic mountain and forest views, and the great old campground keep it a favorite with sightseers and photographers.

Twenty-five miles south of Hood River is one of the most photographed lakes in the nation. Lost Lake has it all: terrific scenery, hiking trails, camping, cabins, fishing, rowboats, and a small store.

Wine connoiseurs will enjoy the Mount Hood Winery, fourteen miles south of Hood River. The small winery specializes in semi-dry fruit and berry wines. The tasting room, accented with antiques and stained glass, opens onto a deck

overlooking the East Fork of the Hood River.

Three Rivers Winery and Hood River Vineyards are two other spots where the people are friendly and the wine delightful.

If you're a beer drinker, you might appreciate the Hood River Brewing Company. It's a new brewery that's gaining state and regional fame. To sample their product you'll want to go to the BrewPub on Cascade Street in downtown Hood River.

Before leaving the Hood River area, follow Highway 35 along the east edge of the city then follow the signs to Panorama Point. Here, the mountains and the Hood River Valley can be seen from atop a small pinnacle. It's a breathtaking view, enhanced even more if enjoyed during the springtime when the valley explodes with fruit blossoms.

Directly across the river from Hood River lies Bingen. The town was founded in 1892 and was given its name because the founder, P.J. Suksdorf, thought it bore similarity to the German town, Bingen-on-the-Rhine. It is the home of a fine winery, Bingen Wine Cellars. Wine tasting time is Thursday through Saturday.

Bingen's sister city of White Salmon, Washington is said to have been purchased at one time for a supply of bacon and potatoes. It's now a thriving little community.

Today, railroads and highways line each side of the gorge, making access easy. For many years the only route through the gorge was via the river. The community of The Dalles was the end of the Oregon Trail and the eastern gateway to the gorge. Anyone who wished to go further had a long stretch of rapids and falls to pass through. Here, too, marked a significant

Following pages: Sunrise on the Gorge

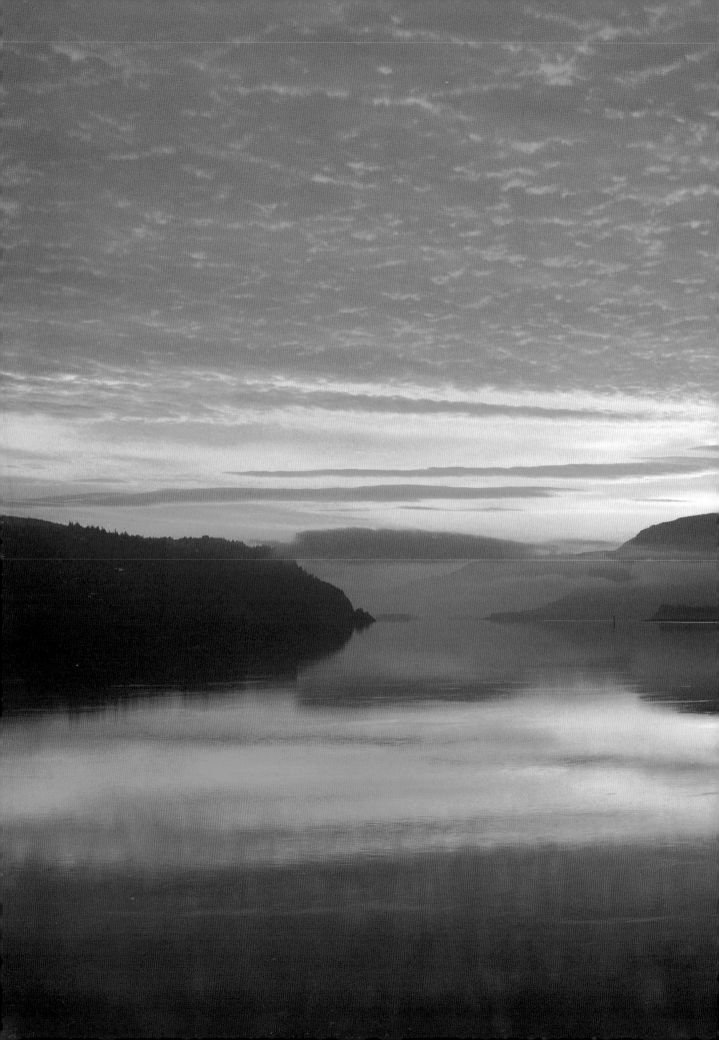

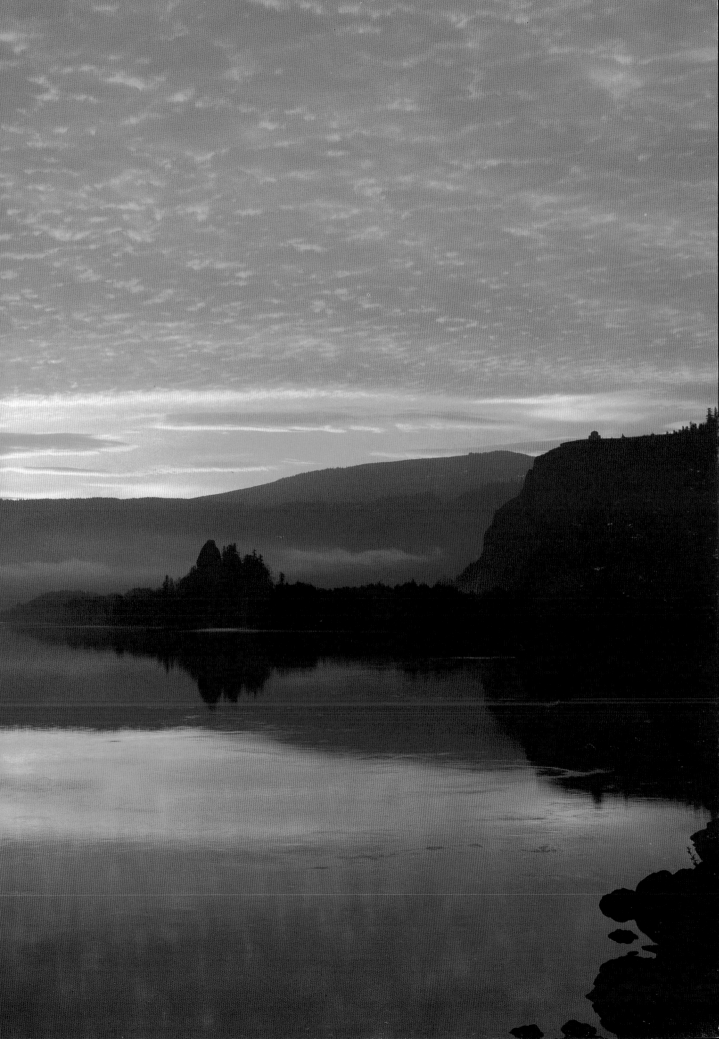

change in terrain. The land near The Dalles is relatively flat and dry; without modern irrigation practices it would be a desert. Just a few miles further west the land surges upward turning into forests and craggy peaked mountains ripe with vegetation. Many travelers found it easier to make The Dalles a permanent stop than to scale the formidable peaks or challenge the rapids of the Columbia.

The pleasant city of The Dalles was named by French canoemen who were employed by early fur traders. Dalle means flagstone, which was often used to flag gutters, and the rocky chute the canoeists had to master, reminded them of a gutter. History buffs visiting The Dalles can enjoy Rock Fort, a stopping place for Lewis and Clark; a look at the Fort Dalles Surgeon's Quarters, which was a strategic military post in the mid 1800's and now houses the Fort Dalles Museum; or watch boardsailers from around the world sail among the world famous winds and waves that churn the waters of the Columbia into a windsurfer's dream. Watching the bright sailboards is like watching a flock of brilliant colored parrots diving and swooping over a crystal blue lake.

The Dalles Dam, built in the 1950's, is another interesting stop. Tourists can hop on the small train and take a tour of the dam. You can see Indian art preserved in the cliffsides here. If you look closely as you travel near the river, you will also be able to see Indian fishing platforms where each season thousands of salmon were netted or speared and brought to shore.

Ten miles east of the dam lies Celilo Park, a monument to

Celilo Falls. Celilo Falls was a favorite fishing place for Indians, and a churning spigot of water generally portaged around by traders and trappers. The falls disappeared forever under the backwaters of The Dalles Dam. The little park makes a lovely stopping spot for highway travelers.

On the Washington side of the gorge in a proximity just slightly northwest of The Dalles are two historic Indian village sites. Both were stopping spots for Lewis and Clark. The one furthest upriver is a village of eight wood houses. Faint trails to an area known as Long Narrows are still visible in some places. The Indians living here were known as the Chilluckit-te-qua. A nearby island, used for burials, is one of many Memaloose Illahee or "Land of the Dead" islands in the Columbia River—"Memaloose" coming from the Chinook work "memalust," meaning "to die." One of the largest of the sacred Indian burial grounds is still further downriver and is known as Memaloose Island. The Indians had a ritual for the dead that involved wrapping the bodies in skins or blankets, often leaving them in a sitting position, surrounding them with items that might be useful in the spirit world, such as knives, bows and arrows, or bead necklaces and cooking utensils for the women. Shelters of poles and bark were constructed around the body. Many of these graves were destroyed by rising waters and by careless, thoughtless white men. Thankfully, Memaloose is protected today as a significant archaeological site.

Other Indians of The Dalles area used this burial ground for centuries, wrapping the bodies in reed mats or buckskin and laying them one upon another in split cedar plank sheds, called vaults. When Lewis and Clark passed through the area in 1806

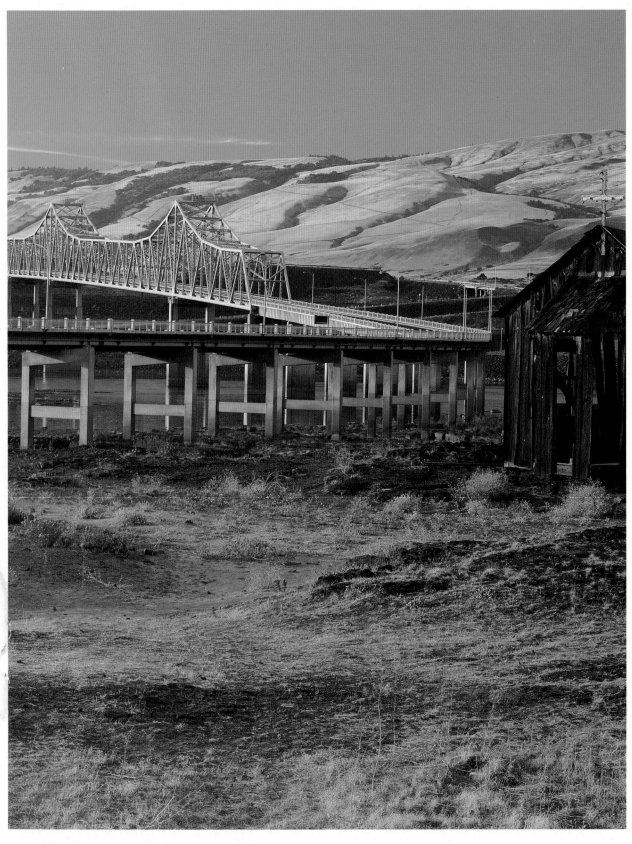

The Dalles bridge and an old abandoned church

Opposite page: Multnomah Falls clad in ice is a spectacular sight

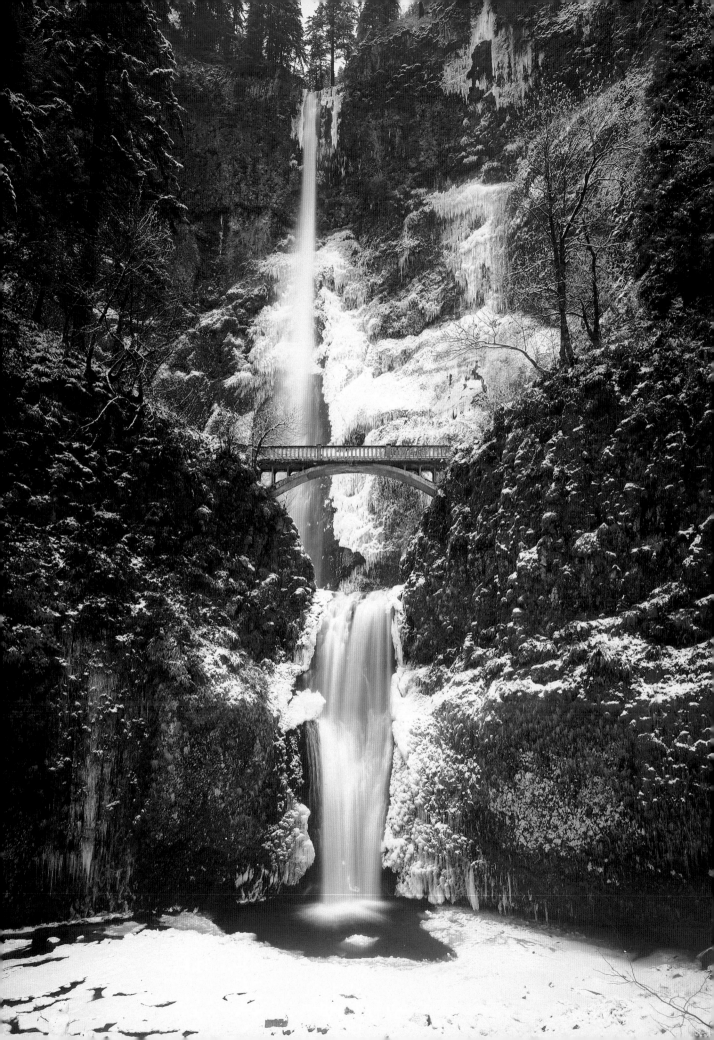

they counted thirteen vaults full of bodies. Tribes passing through The Dalles area buried their dead according to their own customs which might have been cremation, in vaults, by rock slide burials, in underground graves, by placing the bodies in trees, or by leaving a body in a canoe placed upon a rocky headland.

One of the men involved as an early keeper of treasures was Sam Hill. Hill was one of several men who spurred the building of the Columbia River Scenic Highway, a highway once noted as "a poem in stone." Samuel Hill's greatest gift to future generations, however, seems to be Maryhill.

Maryhill is a stone castle on the north side of the Columbia River, built high on a windswept plateau. The 7,000 acres of land upon which Maryhill still sits was purchased with the intention of establishing a Quaker agricultural community. That plan never developed since the steadfast Quakers balked at desert living, but, in 1914, plans for Maryhill did come to fruition.

The eccentric Mr. Hill, when asked why he built Maryhill, would reply according to his mood. Sometimes he declared he built it to have a suitable entertaining place for his friend, King Albert of Belgium. Other times he said it would serve as a fortress to keep enemies from invading North America via the Columbia River. And whether by true intent or not, he sometimes said it was to be a residence, or maybe a museum. In any case, he was influenced by Loie Fuller, who guided him into establishing Maryhill as the museum it is today.

Loie Fuller was a second-rate dancer who made it to Paris and there accrued some small fame. Fuller seems to have been

a first-rate opportunist—certainly an ambitious and clever girl. Just as Fuller's Paris stardom began fading, she learned her old friend Sam Hill had this unfinished castle seemingly waiting for her talents. Fuller proposed she create a museum of French art, using her energy and Sam Hill's money. Some of the earliest art she acquired was rather dubiously titled as "art", but eventually her efforts and the generousity of some fine people helped Maryhill evolve into a remarkable museum.

Maryhill houses an internationally recognized collection of sculpture and drawings by Auguste Rodin. Also notable is the Queen Marie Gallery, named after the Roumanian queen who visited the museum and formally dedicated it in 1926. And for a truly unique opportunity visitors to the museum should see the French fashion mannequins that were conceived by renowned fashion designers hailing the rebirth of the fashion industry at the close of World War II. Most important to the continuance of Columbia River Gorge history is the extensive Native American collection which exhibits rare prehistoric rock carvings, baskets, beadwork and other treasures.

Just beyond Maryhill, Sam Hill left another legacy. He built a replica of the original Stonehenge. Hill believed the original Stonehenge had been used as a sacrificial site, so, to honor the dead of World War I, he constructed the replica to remind society that "humanity is still being sacrificed to the god of war." The monument lies three miles east of the museum, just off Highway 14.

Most fittingly, Hill's crypt, a short walk southwest of the Stonehenge replica, is located on a bluff overlooking the Columbia River Gorge.

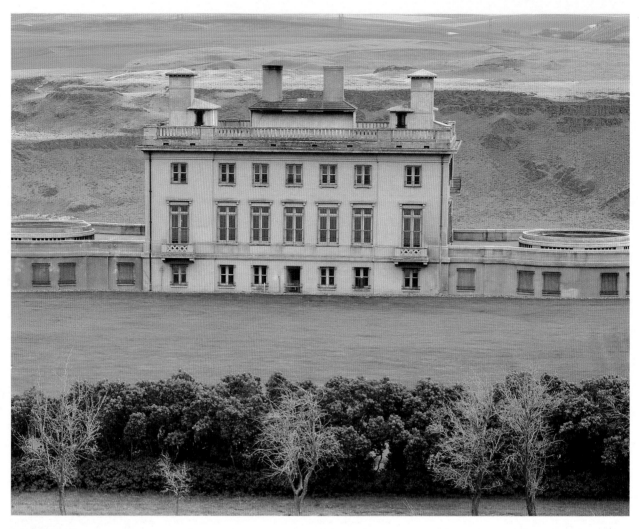

Maryhill Museum

Flowers at Maryhill

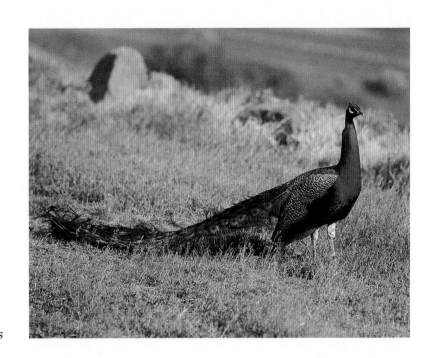

One of the Maryhill Peacocks

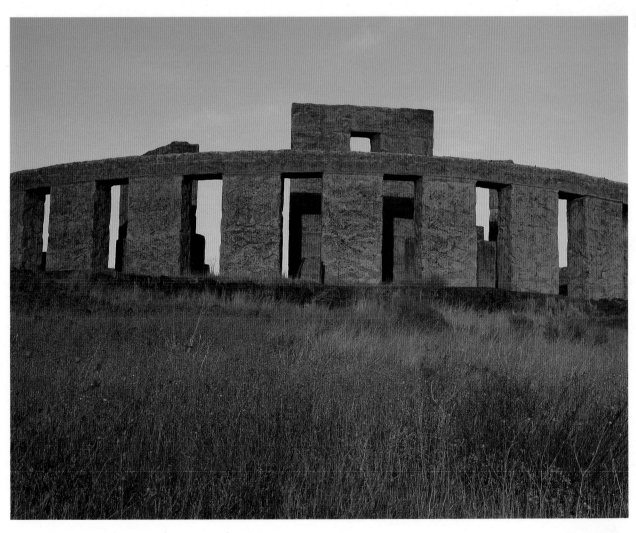

Stonehenge

For many, the epicenter of the magic that permeates The Gorge can be found in one small spot about ten miles west of Maryhill called Horsethief State Park. It is not the park itself that pulls you and lingers in your memories, but the presence of an Indian drawing, Tsa-gig-la-lal, known as "She Who Watches You As You Go By," or, more commonly, "She Who Watches." She is a remarkable combination petroglyph and pictograph of indeterminate age, staring out across the waters of the Columbia River Gorge, keeping forever her secrets of the hardships, the glories, the day-to-day toils of those who have passed her way in centuries past and perhaps for centuries into the future.

From tourists with heads cocked backward to gasp at Multnomah Falls, to windsurfers carving Columbia River waves, to bare-legged children sticking their feet in cool waters, may Tsa-gig-la-lal watch over The Gorge so it can forever retain its mystery, its magic, its lure.

About the Photographer

We think he's terrific! Many others apparently do also, as Craig Tuttle has become "The Rising Star" of the northwest photographic community. This young photographer credits much of his recent success to his insatiable desire to capture each scene from a fresh, new angle whenever possible. This gives Craig's work that unique, brand new look that all his fans cherish and appreciate.

The enthusiastic acceptance of his artistic talents has led to the publishing of his works in just about every media available to photographers. His work appears in books, calendars, on posters and greeting cards; and publishers, industrial and commercial firms, as well as government and institutional clients are keeping him busy.

Craig is a native Oregonian who has followed a rather surreptitious route to his chosen field of photography. An outstanding high school athlete, knee injuries brought to a close a promising athletic career. Anxious to strengthen his knees, he took up mountain climbing. Awe struck with the beauty of the mountain wilderness, he searched for a way to record it for his friends. The camera was selected, and the rest is history.

Your continued support guarantees more exposure for this talented artist in future publications.

About the Author

"I have family and friends living on the Oregon Coast," says Linda Sterling-Wanner, "so I know first hand the joys of this refreshing locale. Oregon's already well known for its beauty, yet few places make you feel more vividly alive than the coast."

"Equally as enjoyable as the stunning scenery is the collection of creative souls this climate seems to nurture. There are wonderful writers, artists and craft people who draw fuel from the powerful essence of the area."

Says Ms. Sterling-Wanner, "The Oregon Coast is a little like ice-cream. There is so much to choose from, you know you'll never sample it all—and you never seem to get enough."

Linda has nearly fourteen years of writing, advertising and marketing experience. She has been an advertising manager, a business editor, a director of sales and marketing, and a freelance writer and editor. In the past several years over 300 of her articles have been in print. She wrote for and was the managing editor of the *Willamette Writer*, a newsletter distributed to over 650 writers, for three years. She also served as president of the Willamette Writers Association for two years and a board member for several additional years.

She currently works as the managing editor for a national publisher that is based in Portland, Oregon.

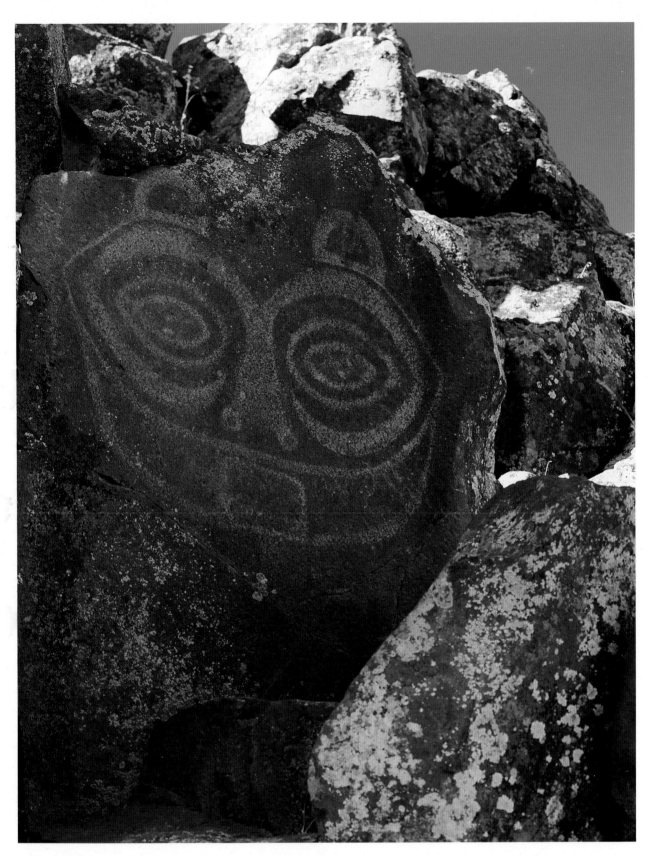

The petroglyph, "She Who Watches," at Horsethief State Park

Rear cover: Wildflowers of the Gorge